C000085764

### IMAGES
#### *of America*

# NAPERVILLE
## ILLINOIS

*Best Wishes*

This book is dedicated

To My Beloved

Lawrence A. Hagemann

"Lisez le reste dans mon
caur, et repon dez moi par
un doux baiser."

"Read the rest in my heart
and answer me with a
gentle kiss."

IMAGES
*of America*

# NAPERVILLE
## ILLINOIS

Jo Fredell Higgins

ARCADIA
PUBLISHING

Copyright © 2001 by Jo Fredell Higgins
ISBN 978-0-7385-1895-4

Published by Arcadia Publishing
Charleston, South Carolina

Printed in the United States of America

Library of Congress Catalog Card Number: 2001091431

For all general information contact Arcadia Publishing at:
Telephone 843-853-2070
Fax 843-853-0044
E-mail sales@arcadiapublishing.com
For customer service and orders:
Toll-Free 1-888-313-2665

Visit us on the Internet at www.arcadiapublishing.com

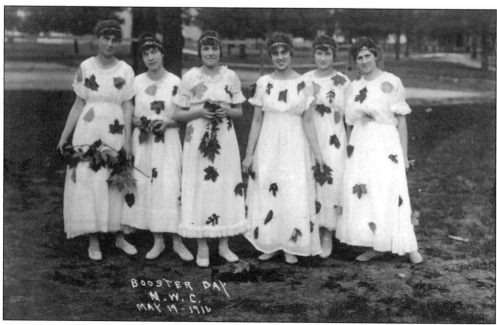

The Legend of Mayfair at North Central College, 1915.

# CONTENTS

# ACKNOWLEDGMENTS

Each history book offers the reader certain flavors, some indelible textures, interwoven and many-dimensional, of times past. This book is a portrait of the manners and mores of long ago memories. I have tried to present a rich photographic history about the city of Naperville that will please the eye, excite the senses, inform, and educate. This is one view of Naperville's engaging past.

Having been blessed by the support and encouragement, time, talent, memories, and photography of those who helped to make my book a reality, I now express my thanks to them.

Grateful thanks go to Larry A. Hagemann, Mayor A. George Pradel, Suzanne Higgins, Sean Higgins, Mary Ann and Brand Bobosky, Rita Fredenhagen Harvard, Evelyn Stearns, Bill Funchion, Pat Sabin, Laurie Kagaan, Mike Davis and Sid Hastings of the Naperville *Sun*, Joyce Elizabeth Wehrli, Joe Weigand and Rita Mowry, Dyonne Brys, Clarita Boldt, Jim Bauer, Ray Kinney, Mary Claire Uselding and Kim Butler of North Central College, Marilyn McKay, President of the Naperville Woman's Club, Jim and Marge Shazer, Bruno Bartoszek, Bob Schraeder, Bill Gommel, Paula Gamble, Susan Seymour, Vannetta Switzer, Mary Ferensen, Doug Navarro, Louise Howard of Naper Settlement, Capt. Jon Ripsky, Mike Lynn, and many residents of Naperville who spoke with me and whose photographs I captured on film.

# INTRODUCTION

*History is the ship carrying living memories into the future.*

—Stephen Spender

History is a composite biography of those who have lived before us and left their social notions, business methods, public opinions, standards of morality, art, music, and photography. It is a kaleidoscope of life that now provides an ever-changing pictorial. About 175 years ago, DuPage County was a wilderness of Native Americans. It was a beautiful land, unknown to white men, peopled by savage tribes. A Frenchman named DuPage settled in 1800 near the joining of the east and west branches of the river that now bears his name. He built a trading post on this fertile earth that lay rich for the coming hand of husbandry.

The early settlers of Naperville, Illinois, included landed gentry and yeoman of Great Britain, Yugoslavia, Germany, Denmark, Scotland, France, Verl Prussia, Luxembourg, as well as Vermont, New York, Minnesota, and Pennsylvania. They arrived in the mid-1800s, and built their homes, barns, and shops, raising their families on homesteaded land. It was an arduous but merry life that included spelling bees, threshing dinners, barn dances, and lots of reading. Lumber, hay, fuel, grain, seed, steers, coal, and cattle all were sources of labor and employment for those early settlers. Fertile prairie land sold for $28 an acre in 1843. Original deeds to farms were occasionally written on buckskin. By 1916, the Peter Olesen farmland cost $180 an acre for 190 acres east of Naperville on a road that was to be called Olesen Lane. In 1901, telephones were installed, followed by gas and then electricity, modern plumbing, the tractor, and milking machines. From this beginning of log cabins and blacksmith shops, from buggies pulled by grey Percheron horses, has grown the dynamic and progressive city of Naperville, Illinois.

Listen, while I tell you of her story.

*We are members of one great body, planted by Nature
in a mutual love and fitted for a social life. We must
consider that we were born for the good of the whole."*

—Seneca

7

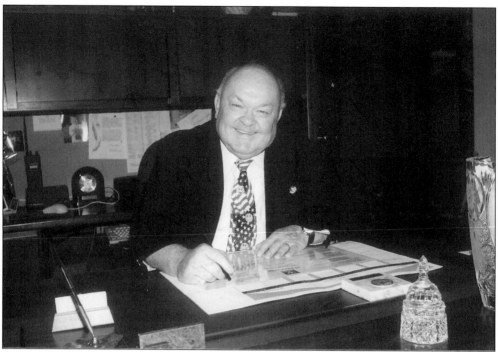

Pictured here is Mayor A. George Pradel. (Photograph by Jo Fredell Higgins.)

*Dear Reader:*

*I would like to take the opportunity to welcome you to the city of Naperville as seen through the eyes and camera of Jo Fredell Higgins. Through painstaking research and diligent application to detail, a wonderful portrait has emerged about the history of this great city and the moments we wish to remember. The poet Longfellow wrote that "His solemn manner and his words had touched the deep, mysterious chords that vibrate in each human breast alike." In reading this book your spirit will be touched and elevated, your knowledge of this particular place and time in the history of our city will be enhanced and enjoyment will abound. Do appreciate the beautiful photographs in this book as they show you both the past and the present Naperville.*

*Enjoy the ride. The view is spectacular.*

*Best Regards,*

*Mayor George Pradel*
*Mayor, City of Naperville*
*In the Year 2001*

# One

# A FARMER IN A FERTILE LAND

## JOSEPH NAPER

*In the early 1800s, there was no regularly traveled road west of Detroit or Cincinnati. The country beyond was unbroken and unknown, inhabited only by Indians and a few scattered settlements. The avenues of travel were Indian trails and buffalo runs. The stars and the sun were the only guides. A singular fact is that where the buffalo would have bivouacked would have been found the largest Indian village which, in turn, became the places which were natural locations for our great cities. The early roads became the trunk lines of the railroads. Thus, they came, the strong and silent heroes who brought their women and children in an ox wagon.*

*Joseph Naper, captain of the Great Lakes sailing vessel the Telegraph, arrived on July l5, 1831, with his group of settlers. He made preparations to build a cabin at what is now the southeast corner of Mill Street and Jefferson Avenue. From DuPage County records we read that they trekked "out to the west branch of the DuPage River, unloaded their belongings and put up their first rude huts about 2 miles north of Bailey Hobson's cabin. In the autumn, the Naper brothers Joseph and John erected a sawmill. By the spring of       1832, the mill was in running order."*

Captain Joseph Naper was a seafaring man, master of the schooner *Telegraph* owned by Captain Benjamin Naper of Ashtabula, Ohio. When Captain Joe was commissioned to sell the ship to a buyer in Chicago, he took several families on the voyage from the Ashtabula River to the mouth of the Chicago, and then by wagon train to the banks of the DuPage River where he, in June of l831, founded Naper Settlement. The settlers survived the first severe winter in their log cabins. Captain Joe staked his claim to the land under the Pre-emption Act of l820, allowing a homesteader 80 acres at $1.25 per acre. The pioneers used the timber for homes and for firewood, clearing the land in this way for later crops. Thus the wooded land beside the river was quickly gone. (Courtesy of the Naperville Heritage Society.)

9

Willard Scott, son of Willard Scott Sr. and one of the beginning leaders of the new settlement, is pictured here on July 18, 1875. Willard Scott Sr., as a young man in his twenties, stopped at a house near Peoria, Illinois, for lodging. His eye took to the comely maiden, Caroline, and in the morning, he thought himself very much in love with her. He asked her father for her hand in marriage. Then he asked Caroline, who demurred. Willard said he would return in two weeks. When he entered the house, he asked Caroline if she had made up her mind. She had, and she would. They wed and began their journey to their new home, 5 miles south of Naperville. Mr. Scott Sr. often told the story of their first night together: "We had the sky for our ceiling. The stars for our light. The trees for our shelter. And the ground for our bed." They were married for 62 years and had a family of five sons. (Courtesy of the Naperville Heritage Society.)

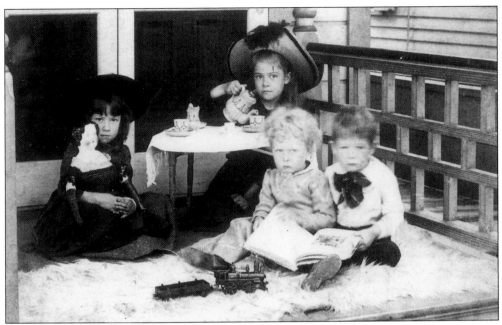

Four unidentified great-grandchildren of Willard Scott Sr. are enjoying an afternoon tea party with their dolls, books, and toy train. The girls are wearing straw hats and pouring lemonade as they look toward the camera on July 21, 1975. (Courtesy of the Naperville Heritage Society.)

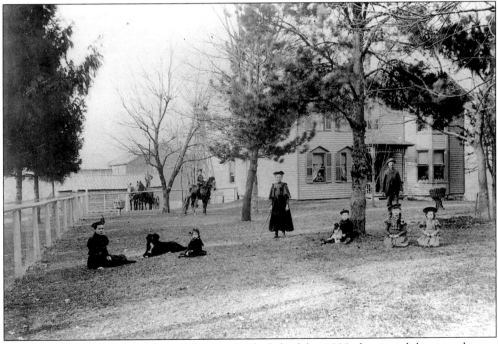

Grandma Riedy is sitting in the window on the far left of this 1898 photograph because she was pregnant! The social mores of that time said that women could not be seen or photographed outside! The Frank Riedy farm was located just east of the Naperville Country Club fence line. (Courtesy of Brand and Mary Ann Bobosky.)

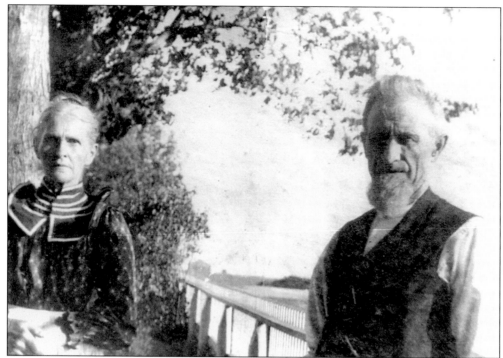

Barbara Weigand and Adam Keller are shown here on a summer porch *c.* 1880s. Barbara was the great, great grandmother of Evelyn Bauer Stearns of Naperville. (Courtesy of Evelyn Bauer Stearns.)

The Towsley family is pictured here, *c.* 1905. Proper dress for women included the white blouse and skirt or dark muslin or damask dress. Men wore dark suits with very stiff, starched collars. Children were dressed in similar fashion with hair bows for the girls. (Courtesy of Rita Fredenhagen Harvard.)

John Fluegge (1823–1900) and
Louisa Lange Fluegge (1827–1909)
are pictured here. John was born in
Zweedorf, Mecklenburg, and Louisa
in Buschmuehlen, Mecklenburg,
near Neubukow. They emigrated in
1852 with her parents and sisters.
First they lived in Provisio Township,
Cook City, then to Downers Grove
Township, DuPage City, and finally
to the DuPage Township, Will City
area, which was south of Naperville.
In 1868, daughter Sophia was born,
met and married Charles Schrader.
This photograph was taken at
Kendig Photographers, c. 1880.
(Courtesy of Clarita Boldt.)

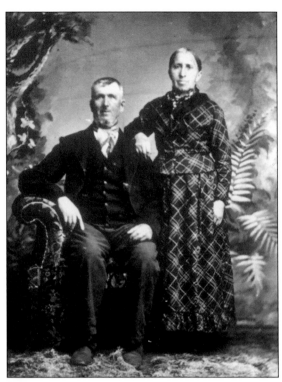

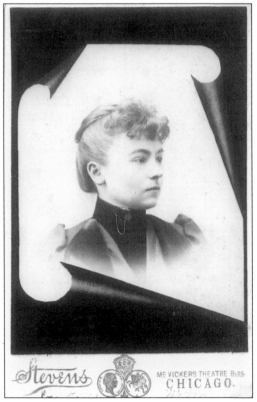

At the McVickers Theatre in Chicago,
Cora Daniels Towsley sat for this beautiful
portrait in 1885. She was the mother of
Grace Towsley Fredenhagen. (Courtesy of
Rita Fredenhagen Harvard.)

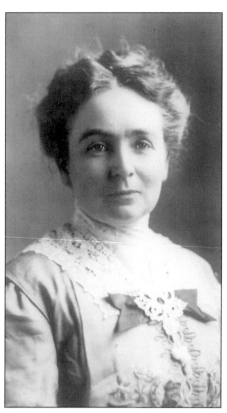

This is another portrait of Cora Daniels Towsley, taken about 10 years later. Notice the beautiful bodice and upsweep of her hair, which was the look for 1895. (Courtesy of Rita Fredenhagen Harvard.)

By the end of the 1800s, business was thriving in the settlement of Naperville. Shown here are two clerks from the Bechmon Harness Shop at the intersection of Jackson and Chicago Avenues. Goods arrived by stagecoach and by train via Chicago. On May 2, 1900, a horseless carriage passed rapidly along the thoroughfare of Water Street. It was the first appearance of an automobile and probably a trial run between Chicago and Naperville/Aurora. (Courtesy of the Naperville *Sun*.)

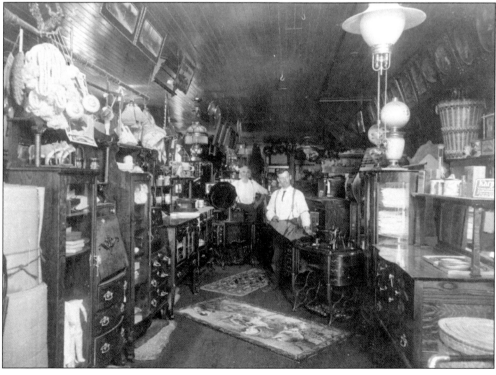

Picture a wonderful summer's day in 1917. President Wilson had given a verbal pledge to the British and French that America was in the war against Germany "to the finish." Naperville was making elaborate preparations for their Homecoming Celebration to be held in June. West-side streets were being paved with curbs and storm drains to be added. And on a patch of summer's green hillside, Grace Towsley Fredenhagen frolicked in the elm tree. "Carefree I am," she seemed to say. (Courtesy of Rita Fredenhagen Harvard.)

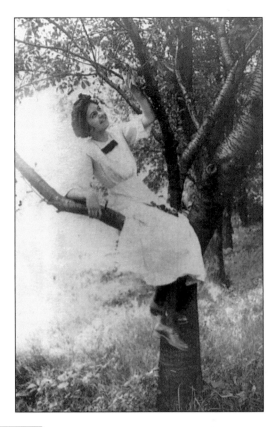

Shown here is the examination of the title, *Naperville, Illinois*, by Joseph Naper. (Courtesy of Jim Bauer.)

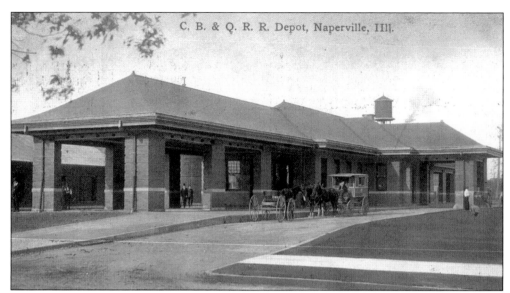

This postcard, c. 1911, is of the CB&Q Railroad Depot in Naperville, Illinois. Both the City of Naperville and North Central College benefited by the arrival of the railroad in 1864. Farmers sold their produce, Kroehler Manufacturing sold furniture, cheese, beer, and forks; plough and wagon manufacturers were also part of the production of goods that would make their way to the Chicago markets and beyond. Naperville citizens were a hardworking group of immigrants with bright hopes for the future of this dynamic city. (Courtesy of Jim Bauer.)

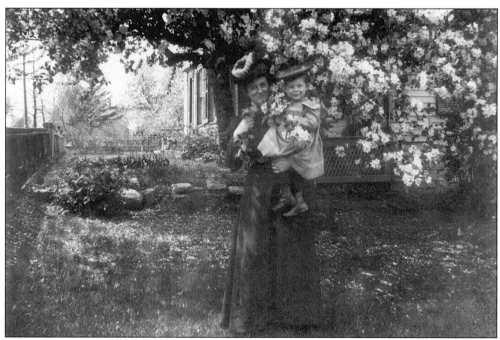

Along the garden wall stand a mother and her daughter in the magnificent spring of the early 19th century. The mom may have been reading magazines, and she might have particularly enjoyed *Parley's* magazine as she enjoyed learning about science. (Courtesy of the Naperville Heritage Society.)

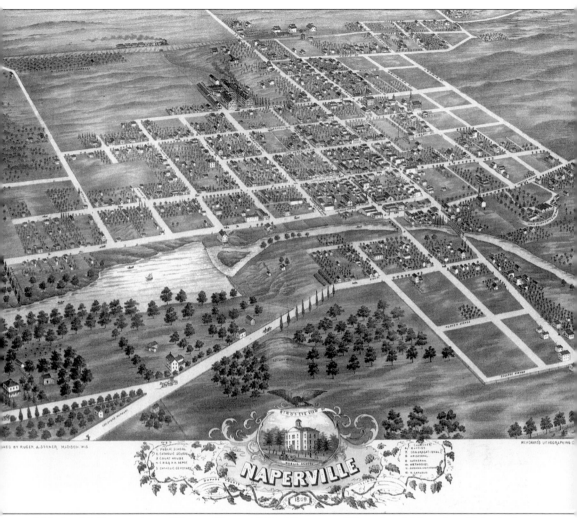

This is a bird's-eye view of Naperville, c. 1869. (Courtesy of Brand and Mary Ann Bobosky.)

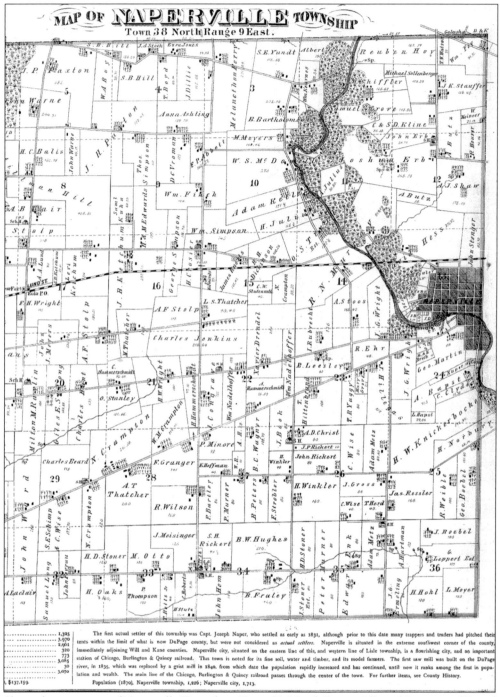

The first actual settler of this township was Capt. Joseph Naper, who settled as early as 1831, although prior to this date many trappers and traders had pitched their tents within the limit of what is now DuPage county, but were not considered as *actual settlers*. Naperville is situated in the extreme southwest corner of the county, immediately adjoining Will and Kane counties. Naperville city, situated on the eastern line of this, and western line of Lisle township, is a flourishing city, and an important station of Chicago, Burlington & Quincy railroad. This town is noted for its fine soil, water and timber, and its model farmers. The first saw mill was built on the DuPage river, in 1835, which was replaced by a grist mill in 1840, from which date the population rapidly increased and has continued, until now it ranks among the first in population and wealth. The main line of the Chicago, Burlington & Quincy railroad passes through the center of the town. For further items, see County History.

Population (1870), Naperville township, 1,826; Naperville city, 1,713.

Shown here is a map of Naperville Township, Town 38, North Range 9 East. (Courtesy of Brand and Mary Ann Bobosky.)

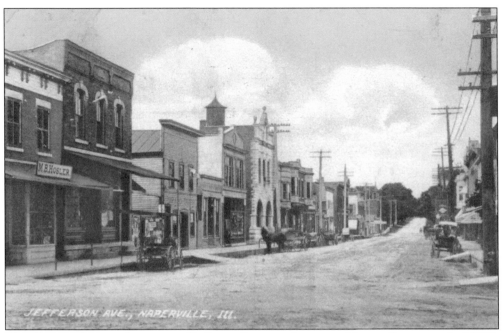

The photographer caught a scene of Jefferson Street in downtown Naperville, postmarked 1909. Both horse-drawn carriages and a 1900 motorcar can be seen in this postcard. The community had been reading the *Naperville Clarion* newspaper, owned by D.B. Givler until 1905, when he sold it to his son, R.N. Givler. (Courtesy of Pat Sabin.)

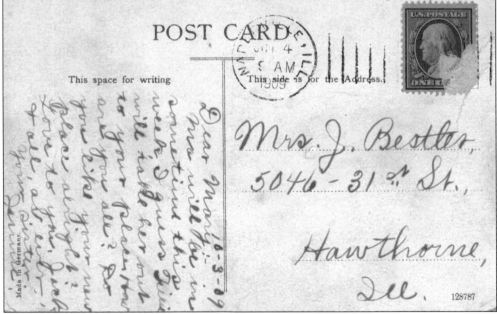

Jennie wrote a fond card to Mary in 1909. There were two mail carriers in Naperville in 1904. That was the same year that the quarrying of stone from the big quarry south of the river ceased. The city water system had begun operations on November 25, 1904, when the steam fire engine was retired. So they would have had fresh water for their tea. (Courtesy of Pat Sabin.)

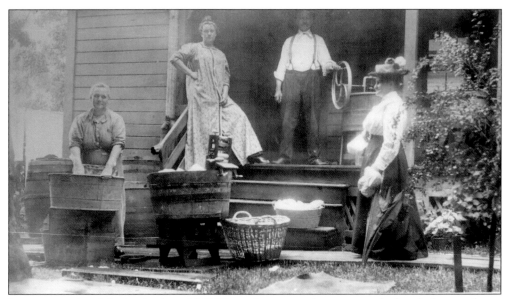

It was a very hot July day in the mid-1900s as the women began to wash the clothes outdoors. Mondays were busy, with many family members helping to scrub, rinse, and hang the family's clothes outside to dry. Large wooden tubs helped them with the tasks. This particular scene was from the Stark family album. (Courtesy of the Naperville Heritage Society.)

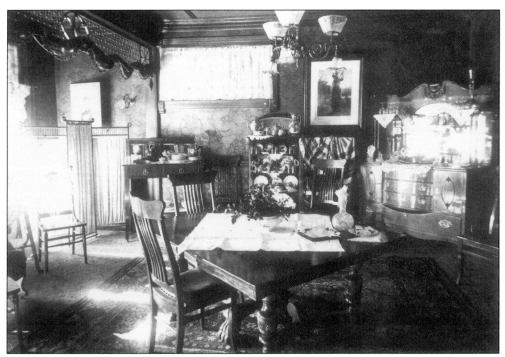

This is an interior glance at the dining room of the Willard Scott house at 15 East Jefferson, Naperville. Natural light helped the photographer to show details of this Victorian home. (Courtesy of the Naperville Heritage Society.)

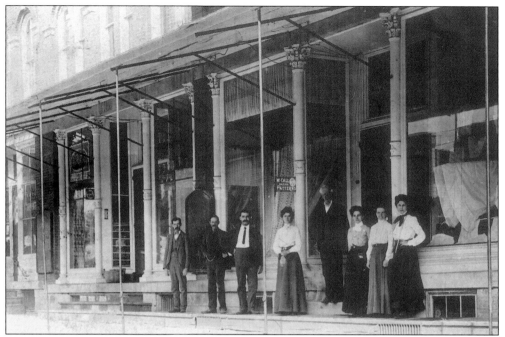

Scott's store in the 1890s was *the* shopping center for a 10 mile radius. Scott's bank served the community for many years until it was bought out by First National Bank. Scott's Hall offered traveling one-night entertainers, dancing parties, and vaudeville acts. Eight employees stood outside the store in this vintage photo. (Courtesy of the Naperville Heritage Society.)

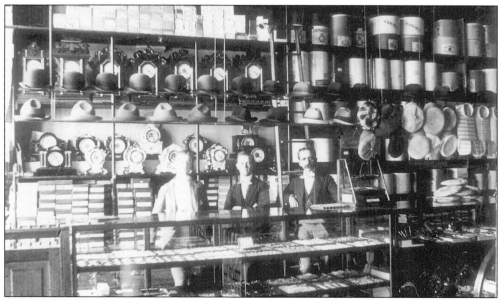

Think of the inventory of this Collins and Durran store! Mercantile business, aside from agriculture, was the chief business of Naperville. Large amounts of goods were sold to the surrounding communities also. Integrity was the hallmark of the merchants, *c.* 1890s. The store was begun in 1879, and sold jewelry, fine watches and clocks, shoes and boots, hats and clothing for gentlemen. (Courtesy of the Naperville Heritage Society.)

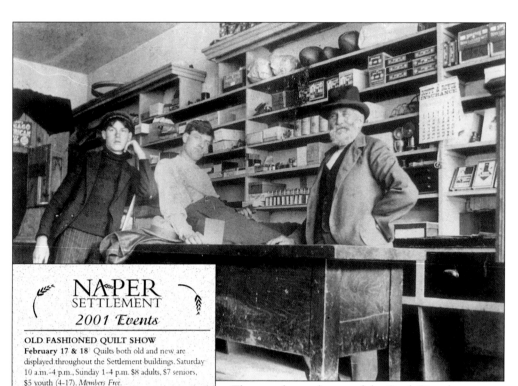

Three male employees of the Stark Bicycle Shop pause in the day's occupations, *c.* late 1800s. There were also two breweries in town, the Messrs. Vaughan and Peck plow and wagon shop that employed 36 men, and two post offices—one in Naperville and one at Big Woods. The Naperville Post Office had an annual income of $1,000 a year in 1857. R. Naper was postmaster. Two large nurseries had imported 30,000 young evergreens and plants from Europe. They also sold trees, fruit trees, and shrubs. (Courtesy of the Naperville Heritage Society.)

This is the Naper Settlement 2001 events flyer. (Courtesy of the Naperville Heritage Society.)

# Two

# MOONLIGHT ON
# THE DUPAGE RIVER
# RIVERWALK

*"Nature is the living, visible garment of God."*

—Goethe

Moonlight, still as paint, lingered over Naperville on the night of June 6, 1931. Naperville was establishing a permanent memorial on the DuPage River that would include 45 acres of park and forest preserve with the river winding between two abandoned quarries. The land was purchased through the efforts of the Permanent Memorial Committee and included donations from 33 citizens. The purchase price was $16,500. Naperville's Riverwalk, approximately 80 acres, is a natural scenic paradise with the DuPage River winding between two beautiful abandoned stone quarries. Its background is historic as well as scenic. In the autumn of 1831, Captain Joseph Naper built his mill there—the first industrial venture begun in Naperville.

The river was an important factor in the development of Naperville, but the mills, dams, and ponds have long since disappeared. In 1842, the settlement was laid out in streets. The unpaved streets were generally 2-by-2.5 feet lower than the board sidewalks that bordered them. This was for the convenience of the carriage trade so patrons could step from their buggies onto the plank boardwalk. There were also some flagstone walks taken from the Naperville quarries. For illumination, there were kerosene lamps set atop posts that were taken care of by the earnest lamplighter. In 1900, the census listed the Naperville population at 2,600.

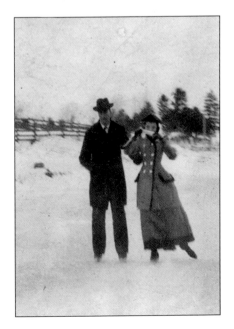

Imagine a frosty winter's day in Naperville, c. 1880s. Two ice skaters are enjoying the frozen DuPage River scene. This was a popular activity then. The man had been enjoying a cigar, which was purchased at the George and William Knoch cigar store. The store closed in 1933. "Learned to skate (Mary did) in puddle in front of house with other girls, often used to go to river a mile west of town and a few times had boys push us down to mill pond 3 miles or so. One time when it was two, three, or six below zero we girls and boys went to river and all but Emma Hannah skated. Emma froze her feet to bleeding. Guy [was] a fine skater and could endure cold." This quote is from the early recollections of Mary Colt Sabin, Naperville, Illinois, 1855–1936. (Courtesy of Pat Sabin.)

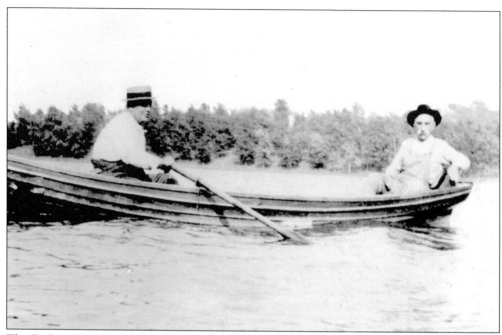

The DuPage River was calm that day in 1920, when Christian Scherer and his brother Harry enjoyed their boat ride. About 90 years before, in 1831, Joseph and John Naper had "trekked out to the west branch of the DuPage River and unloaded their belongings. They put up rude huts at a location 2 miles north of Bailey Hobson's cabin." Soon they were laying logs, which they held in place with stones, across the water to build the dam. By the spring of 1832, the first mill was up and running. (Courtesy of Dyonne Brys.)

In 1895, this photo was taken of Christian and Harry Scherer. Naperville was an agrarian community. Grain and cattle were shipped to the Chicago markets, and the Chicago Board of Trade set the farm prices. The city had begun to use the new material called "concrete." The southern addition to "Old Main" was added. Naperville as a city had only been organized for five years. (Courtesy of Dyonne Brys.)

The year was 1872, and Mary Stenger was to wed Christian Scherer. Formal portraits of this kind were in vogue for wedding couples. (Courtesy of Dyonne Brys.)

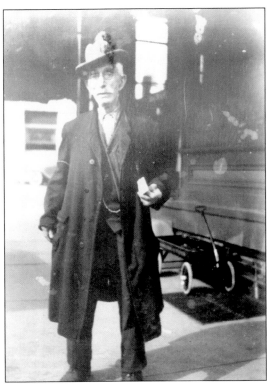

On his wedding day, Christian Scherer posed for this formal portrait. His watch fob was popular for men in 1872. (Courtesy of Dyonne Brys.)

In 1930, Christian Scherer posed for this photograph in front of the family home at 112 South Webster Street in Naperville. It was the time of the Great Depression in America, and Naperville's population of 5,000 worked to relieve hardship. Local groups such as the Knife and Fork Club helped with the soup kitchen, which operated during the winter of 1932–33. (Courtesy of Dyonne Brys.)

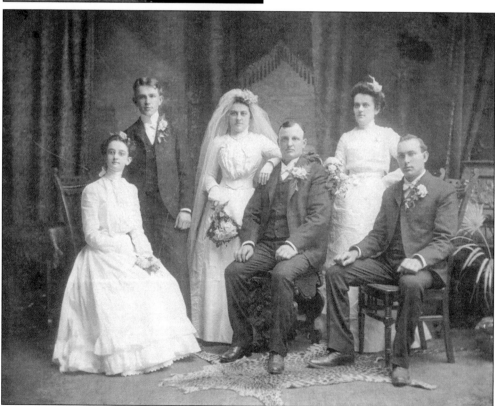

This is a May 1901 wedding portrait of Jim Bauer's grandparents. They are, from left to right: unidentified, William Baier, Catherine Baier, Valentine Bauer, Lena Baier Hagen, and Paul Hagen. (Courtesy of Jim Bauer.)

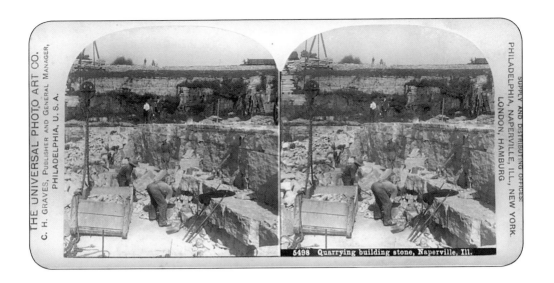

Shown here are fantastic views of the stone quarry in Naperville by way of two unique stereoviews! Mike Lynn obtained these stereoviews, which were originally shot by the Universal Photo Art Company, printed in Philadelphia, Pennsylvania, c. late 1800s.

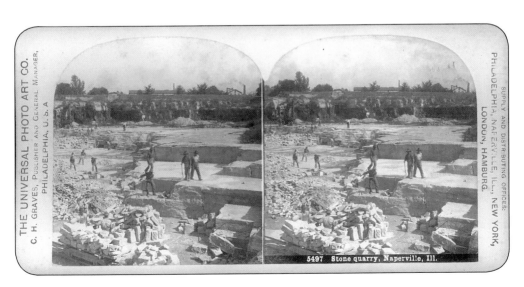

Edward and Ralph Mertz are pictured on the lawn in front of their home at 112 South Webster, c. 1925. They were quite possibly planning a drive along the riverfront on this warm summer's day. A picnic hamper filled with chicken salad and deviled eggs would be their lunch at midday. Off the vine they had picked the raspberries, hot from the summer sun, which would be an extra treat for their dessert. (Courtesy of Dyonne Brys.)

On a waning September afternoon, this couple lingers in 1948. The sun was growing lengthening shadows as they discussed their upcoming nuptials. Together, they did not want to see the moon rocking in the night sky, as that meant that they would, indeed, have to part. Their names are unrecorded. (Courtesy of Mary Schrader and son Bill Schrader.)

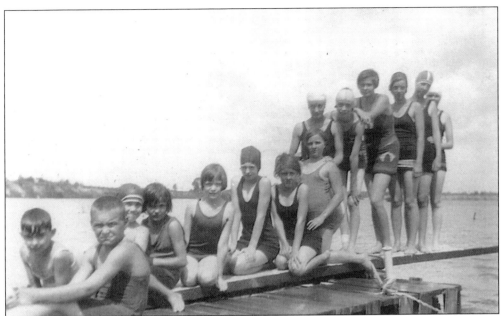

On a languid summer's day in 1930, children from the Boardman, Boughton, Grommon, and Clow families went swimming at Lake Renwich in Plainfield, Illinois, just south of Naperville. Thoughts of schoolwork from Miss Lindsay, their Naperville grade school principal, had receded for the time being! The water's invitation was so beguiling! (Courtesy of Mary Schrader and son Bill Schrader.)

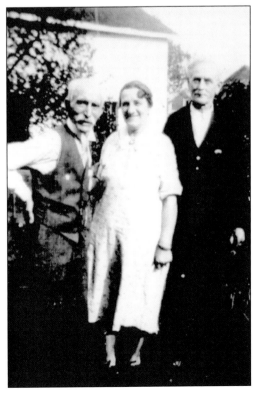

In 1925, father Christian Scherer, his daughter Emma, and her husband Ed posed for this photograph. They may have just enjoyed their dinner of fried chicken, noodles, and fruit salad. (Courtesy of Dyonne Brys.)

In 1945, the year of my birth, Edward, Katie, and George Mertz smiled at the high noon of the day. It had been fun seeing the film *To Have and To Have Not* with Humphrey Bogart and Lauren Bacall. Bogart was quoted as saying he had "signified my intentions" toward actress Bacall. Jukebox records were selling three for 57¢, brown and white saddle oxford shoes sold for $3.99, and a first class postage stamp was 5¢. Homecoming for the families of the war included reminders of ration rules. Red stamps were issued for meat, fats, and fuel oils. Blue stamps were for processed foods and fruits. Sugar was obtainable with Book 4, No. 34 for a 5-pound sack. Shoe stamps were not valid until mid-summer, and gasoline was available with A coupons, each good for 5 gallons. (Courtesy of Dyonne Brys.)

Celebrating a friend's birthday brought Frank Knippen, Ed Staffeldt, and another male friend together on this balmy summer's day in 1930. The dapper Frank had just driven over the newly opened Washington Street bridge and was looking forward to seeing his sweetheart, Pearl Mertz. Naperville's population stood at 5,100. (Courtesy of Dyonne Brys.)

This is a photo of the Mertz home at 112 South Webster Street in Naperville. It was 1938, and that afternoon on the radio they listened as President F.D. Roosevelt spoke about the New Deal. Demand for gold sent the London price to $34.75 an ounce. In Chicago, crop experts anticipated the third largest wheat crop in U.S. history. Pearl S. Buck was awarded the Nobel Prize for Literature for her novel *The Good Earth*. (Courtesy of Dyonne Brys.)

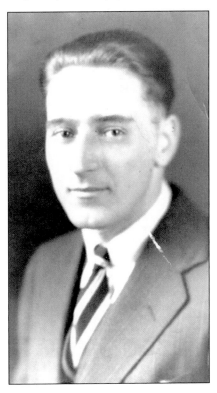

In 1931, Ralph Mertz had this formal portrait taken at Donald F. Murray in Aurora, Illinois. Ralph drove a Kroehler furniture truck and was known for his courteous delivery. (Courtesy of Dyonne Brys.)

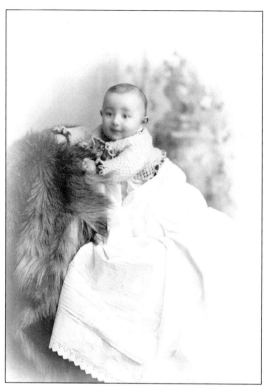

Harry Scherer (1895–1966) smiled for this Kendig portrait in 1895. DuPage County at this time was served by six rail lines—all but one providing both passenger and freight service. The freight line was the Elgin, Joliet & Eastern Railway and the only north-south route in the county. It connected Illinois steel mills in four counties. Electric rail systems would be introduced to DuPage County in 1902. They offered pollution-free and faster modes of transportation. (Courtesy of Dyonne Brys.)

In 1919, Ralph, Emma, and Raymond Mertz are pictured in front of their house on Webster Street in Naperville. It was the year that the Oratorio Association would form at Northwestern College. It was the predecessor of the Naperville Chorus. There were 184 charter members. (Courtesy of Dyonne Brys.)

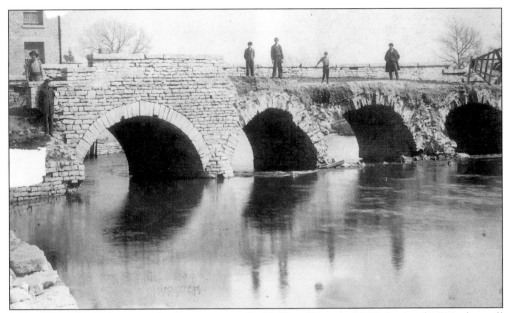

Robert Reed built this stone bridge spanning the DuPage River in 1856. In April 1892, the wall fell in, and the bridge was torn down in the summer that year. A new bridge was then erected. The materials might have been purchased from the Naperville Stone Company, which had been founded in 1884 by Ernst Von Oven and his nephew B.B. Boecker. The company would cease operations in the late 1890s. (Courtesy of the Naperville Heritage Society.)

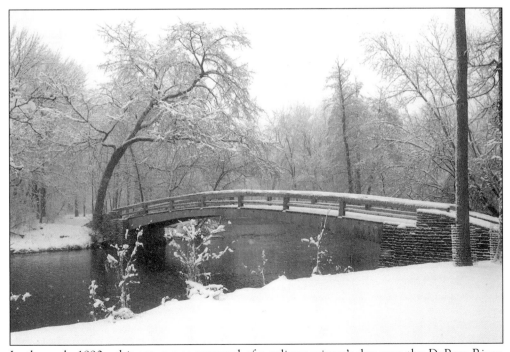

In the early 1990s, this scene was captured of a solitary winter's day over the DuPage River. Winter's serenity lay still before the camera, and one could imagine the peace that could be found there. (Courtesy of Bill Gommel, The Picture Man, Inc.)

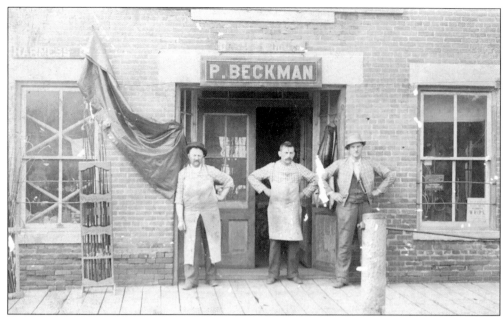

Three employees of the P. Beckman store in downtown Naperville take a lunchtime recess to pose for this photo, *c.* early 1900s. (Courtesy of *The Naperville Sun.*)

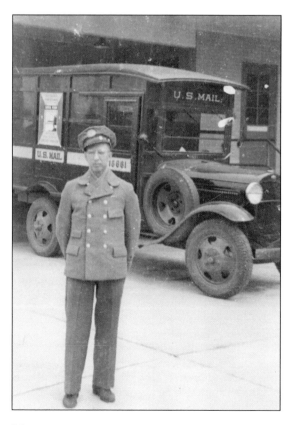

Julian Ory stands in front of his U.S. Mail truck in 1929. In 1904, two city mail carriers had been allowed by the Post Office Department in Washington, D.C. to serve Naperville. There were several more by 1929. He may have paused to look up at the "Graf Zeppelin" on its world-encircling flight. Its big silver bag was clearly visible as it approached from the west accompanied by a group of airplanes. It was headed for Chicago! (Courtesy of *The Naperville Sun.*)

# *Three*

# A TIMELESS VILLAGE
## NAPER SETTLEMENT

*"And lure me back along the ways of time's all-golden yesterdays."*
—James Whitcomb Riley

With pioneer energy, the fertile soil and comely climate of Naperville blossomed into fields of grain, cabin homes, and civilized institutions of church, school, and government. To Naperville came the new Americans, bold and strong, and brave farmers who cleared the forests and planted crops, who raised families and learned to live in peace with nature and with the Native Americans.

In 1860, a New York Herald *reporter wrote, "Naperville is a quiet prairie town of 2,000 inhabitants. To visit from Chicago involves a perilous stagecoach journey of 30 miles. No telegraphs flash news, and the mails are dilatory; all around are level prairies, and each house stands out boldly. . . all painted white, all comfortable looking."*

Naper Settlement, a living history museum village of 19th century homes, shops, and buildings, depicts this story of daily life. To preserve those traditions, 12 volunteers founded the Naperville Heritage Society in 1969, and set about the task of relocating an 1864 Gothic Revival church that had been slated for demolition.

Another building of note is the Martin-Mitchell Mansion, c. 1883. Etiquette was quite formal, and a lady was required to wear a corset in that part of the house. Since closets and doors could be counted for tax purposes, wardrobes and windows took their places. A parlor game popular then was "Fluffy Feather." It was played by blowing a feather in the air. When the feather dropped to the table, that player was eliminated.

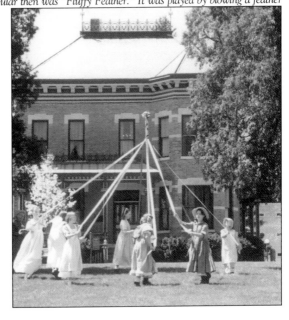

This May Day celebration took place at the Naper Settlement several years ago. May Pole dancing is a joyous rite of spring as part of May Day celebrations. This old English tradition suggests that hawthorn branches are to be brought in from the woods, and the season is to be extolled with song and flowers. Children make wallpaper or tissue May baskets, fill them with some popcorn, candies, wild flowers, and apple blossoms. Then they hang them surreptitiously on the neighbor's door. (Courtesy of Bill Gommel, The Picture Man, Inc.)

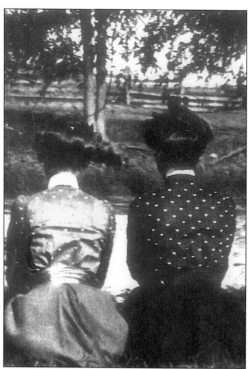

Emma and Eva Keller sat on the banks of the DuPage River in 1885, and a glorious photograph was captured for our enjoyment today! Emma spoke of her desire to teach schoolchildren while Eva wanted to be married. They had been milking cows for their father but decided to rest a bit to the east of the farm as the meandering river went slowly, in summer fashion, past. (Courtesy of Joyce Elizabeth Wehrli.)

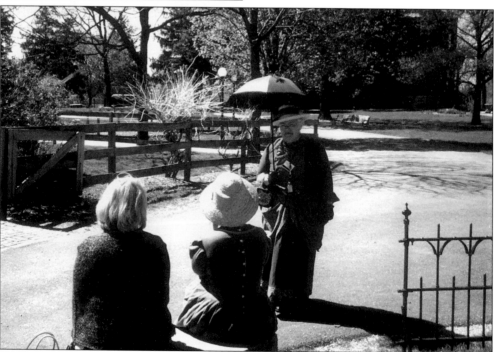

A similar scene presented itself at the Naper Settlement on Friday, April 27, 2001, as I walked the grounds on a beautiful, 75-degree day. Joan Pinckney and Kathy Skwara (with hat) were seated, while Phyllis Goerling approached wearing a vintage outfit. What a fitting counterpoint this was to the 1885 photo that had captured my fancy earlier! (Photograph by Jo Fredell Higgins.)

Phyllis Goerling had lived in Naperville from 1944–53, and was a Naperville High School graduate in 1949. She graduated from North Central College, class of 1953. Phyllis returned to the city in 1987, and now is a volunteer with the Settlement. Here she holds her black parasol, which compliments the period costume she is wearing. This was a most wonderful April day in the year 2001! (Photograph by Jo Fredell Higgins.)

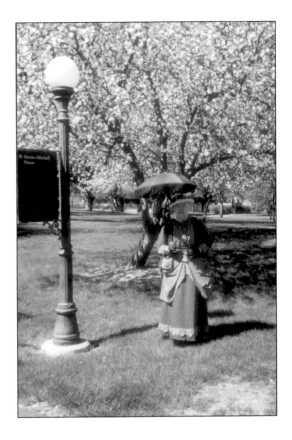

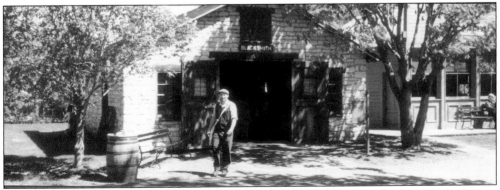

Pete Noll is out for a quick stroll before returning to the blacksmith shop at the Naper Settlement. Another beautiful April day with temperatures about 75 degrees was enjoyed by all the Settlement guests on that April 27, 2001. (Photograph by Jo Fredell Higgins.)

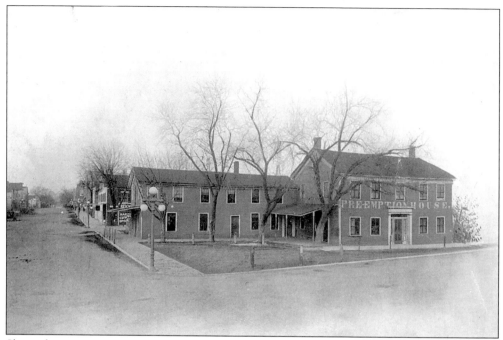

Shown here is an amazing photograph of the Pre-Emption House built by George Laird in 1835. The inn rambled "pleasantly from room to room, a masterpiece of misalignment." It is thought that Abraham Lincoln slept there on the night before his meeting with Stephen Douglas in Chicago for one of their famous debates in 1858. Douglas is also thought to have slept in Naperville that night at the home of his friend, Judge J. Murray. The next morning, Lincoln addressed the crowd gathered from the second floor doorway at the west end of Pre-Emption House, as artist Lester E. Schroeder (1907–1984) has depicted. (Courtesy of Joyce Elizabeth Wehrli.)

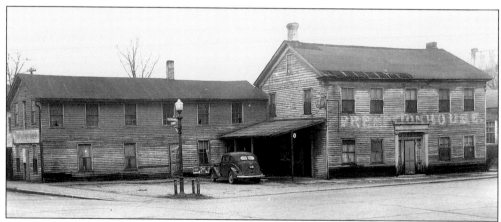

Jessie Oldham ran the Pre-Emption House saloon. This is a postcard c. 1946. The Pre-Emption House was the largest hotel in continuous use (91 years) west of the Allegheny Mountains. The hotel had 19 bedrooms, an office, a kitchen, a dining room, a sitting room, a maid's room, and a large sample room. It was constructed "of oak trees which grew in the area, and from locally grown trees came the walnut clapboards. The main rooms had tongue and groove white rock maple floors. All the interior trim was of white pine." (Courtesy of Joyce Elizabeth Wehrli.)

The Pre-Emption House is pictured here in 1905. Notice the hitching posts for horses and the women's long skirts. The first Saturday of the month was Horse Market Day, and men from the area went there to buy and trade horses. Emma Hiltenbrand would serve the men all they could eat dinners for $1. (Courtesy of Joyce Elizabeth Wehrli.)

Samuel Hiltenbrand and Dutch John Bolkey are pictured about 1915 outside the Pre-Emption House. They may have been waiting for delivery of beer or bread for the day's meals. Fifteen to twenty guests would regularly eat their meals at the Pre-Emption House daily. (Courtesy of Joyce Elizabeth Wehrli.)

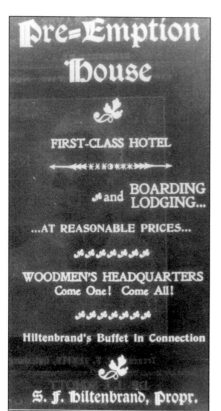

Samuel Hiltenbrand purchased the Pre-Emption House in 1893, and would run this ad for the establishment. (Courtesy of Joyce Elizabeth Wehrli and her book *We Are Family, History of the Pre-Emption House and The Gertrude Hiltenbrand-Wehrli Family.*)

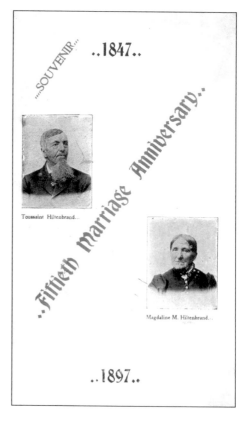

Tousaint Hiltenbrand was born in Alsas, Germany, on November 1, 1824, and emigrated to Illinois on July 1, 1844. Magdalena M. Clementz was born in Alsas, Germany, on April 22, 1824, and emigrated to Illinois on July 23, 1845. They were wed in Chicago on October 23, 1847, at St. Peter's Church. This booklet page was in honor of their golden wedding anniversary on October 23, 1897. (Courtesy of Joyce Elizabeth Wehrli.)

HISTORIC AMERICAN BUILDING SURVEY
AN ILLINOIS EMERGENCY RELIEF COMMISSION PROJECT
DISTRICT OF NORTHERN ILLINOIS

PURE OIL BUILDING      CHICAGO      35 E. WACKER DRIVE
ROOM No. 1512                           PHONE No. CENTRAL 7819

EARL H. REED, DISTRICT OFFICER

SPONSORED BY
ILLINOIS STATE HISTORICAL LIBRARY
U. S. DEPARTMENT OF THE INTERIOR
  OFFICE OF NATIONAL PARKS
AMERICAN INSTITUTE OF ARCHITECTS
THE LIBRARY OF CONGRESS
FEDERAL EMERGENCY RELIEF ADMINISTRATION

July 1, 1935

Hiltenbrand Estate,
Care of Mrs. Laura Barenbrugge,
Naperville, Illinois.

Gentlemen:

At the order of the
Office of National Parks, Interior Department, Washington, D.C., I have the honor
of enclosing, herewith, a certificate showing that the Pre-Emption House, Naperville,
Illinois, now owned by you, has been measured
by the Historic American Buildings Survey,
Northern Illinois District, for record in the
Library of Congress.

The name of the original
owner has been included in the certificate
itself, but I would like to express the
official thanks of the Survey to you as owner,
for your cooperation and permission to measure.
You have, thereby, done a public service.

Yours very truly,

District Officer Northern Illinois

---

·DEPARTMENT·OF·THE·INTERIOR·
·WASHINGTON·D·C·
·THIS·IS·TO·CERTIFY·THAT·THE·
·HISTORIC·BUILDING·
·KNOWN·AS·
*Pre-Emption House*
·IN·THE·COUNTY·OF·
*Du Page*
·AND·THE·STATE·OF·
*Illinois*
·HAS·BEEN·SELECTED·BY·THE·
·ADVISORY·COMMITTEE·OF·THE·
·HISTORIC·AMERICAN·
·BUILDINGS·SURVEY·
·AS·POSSESSING·EXCEPTIONAL·
·HISTORIC·OR·ARCHITECTURAL·
·INTEREST·AND·AS·BEING·WORTHY·
·OF·MOST·CAREFUL·PRESERVATION·
·FOR·THE·BENEFIT·OF·FUTURE·
·GENERATIONS·AND·THAT·TO·THIS·
·END·A·RECORD·OF·ITS·PRESENT·
·APPEARANCE·AND·CONDITION·
·HAS·BEEN·MADE·AND·DEPOSITED·
·FOR·PERMANENT·REFERENCE·IN·THE·
·LIBRARY·OF·CONGRESS·

·ATTEST·
·District·Officer·

Harold L. Ickes
·Secretary·of·the·Interior·

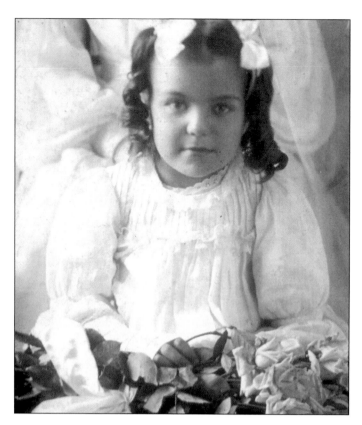

This beautiful little girl was Gertrude Hiltenbrand, who was born in 1897, to Sam and Emma Hiltenbrand. Naperville's population was 2,216. She is five years old in this white gossamer dress, white hair ribbons, and holding a bouquet of roses. This photograph is so billowy and filmy it actually seems spun by the angels. (Courtesy of Joyce Elizabeth Wehrli.)

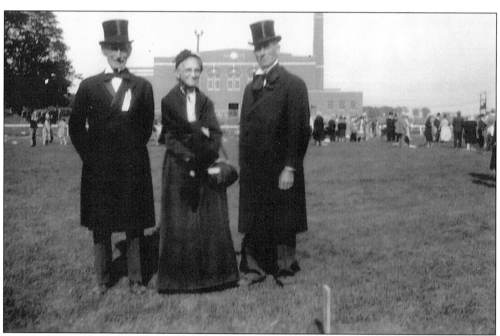

George Keller, Mary K. Seiler, and Mr. Keller stop by the fieldhouse at North Central College during Naperville's Centennial celebration in 1931. (Courtesy of Joyce Elizabeth Wehrli.)

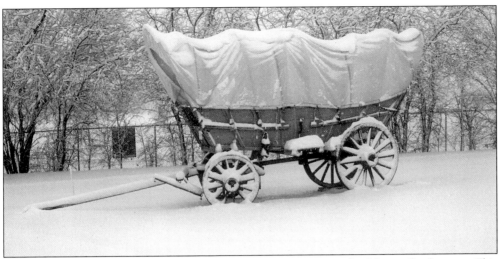

Pictured here is a quiet scene during the winter of 1996 at the Naper Settlement. This Conestoga wagon sits nearby a log cabin on the grounds of the Settlement. This 12-acre living history museum was given in the will of Caroline Martin-Mitchell to the city. She was the daughter of the brick and tile-manufacturing magnate, George Martin Jr., and this 204.26-acre stretch of land housed the Martin family's Pinecraig mansion built in 1883. Part of the land became the location of Naperville Central High School, which neighbors Naper Settlement. In compliance with her wishes, however, the city agreed to preserve Pinecraig mansion as a museum on the remainder of the estate. Today, it is known as the Martin-Mitchell Museum. The museum inside indicates a time of grace with furnishings that are sumptuous and quaint. The Naperville Heritage Society was formed in 1969, to preserve these historic grounds. (Courtesy of Bill Gommel, The Picture Man, Inc.)

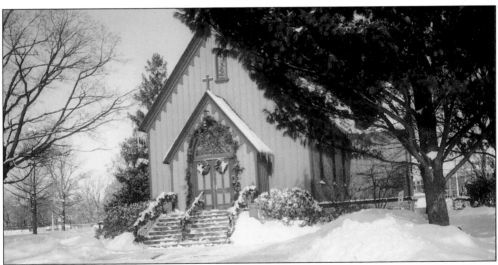

In 1969, St. John's Episcopal Church, one of the oldest churches in northern Illinois opening in 1865, was slated for the bulldozer. The heritage society held a massive fund-raiser and moved the chapel with a Mack truck to the Martin-Mitchell estate. St. John's is now the Century Memorial Chapel. A seven-year project was completed in 1990, to renovate this Prairie Gothic structure by repainting the interior and exterior and also involved the restoration of the pews and altar. (Photograph by Jo Fredell Higgins.)

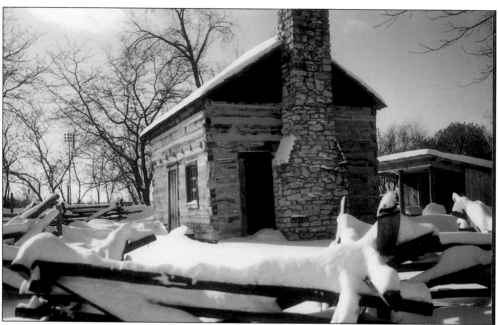

The stillness of the 19th century seems evident in this composition with the sun directly overhead on a crisp December day, 2000. This stone house was intended to be a temporary shelter in the 1830s until the family could move into more permanent lodgings. It is called a "Log House." (Photograph by Jo Fredell Higgins.)

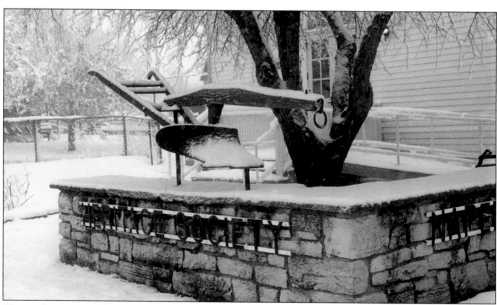

Shown here is another winter scene at Naper Settlement, December 1998. The caprice of the fallen snow had covered the grounds with its innocent whites. No footprints could be seen, and it was lovely to behold this glimpse of the past in solitude. This was intended to illustrate the dedication of the Heritage Society volunteers to the Settlement. The Memorial Wall has been relocated. The plow will return as the symbol of the hardworking and sincere volunteer. (Courtesy of Bill Gommel, The Picture Man, Inc.)

August "Gus" Hiltenbrand was born to Sam and Emma in 1895. Here he is shown in 1917 in uniform, dignified and proud to serve his country. (Courtesy of Joyce Elizabeth Wehrli.)

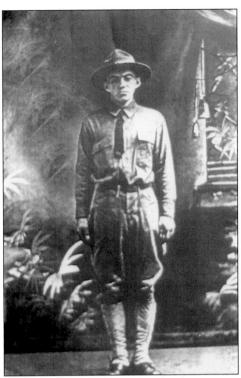

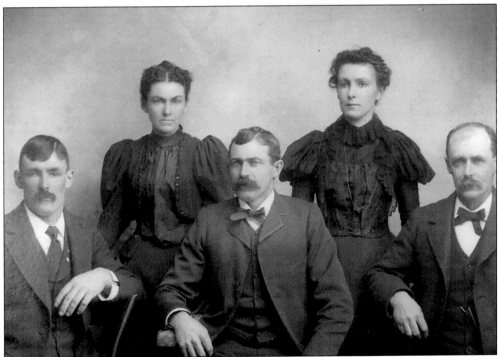

Pictured here, from left to right, are: William, Elizabeth Kohley, Andrew, Mary Drendel, and Henry Wehrli. These were the five children of Joseph and Elizabeth Schmitt Wehrli. This photo was taken in 1898. (Courtesy of Joyce Elizabeth Wehrli.)

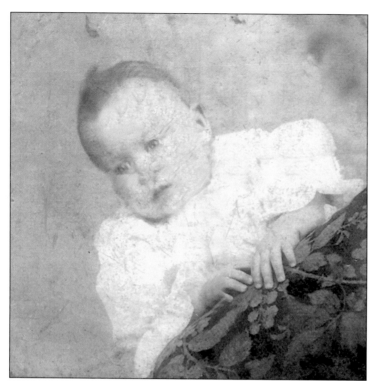

What a treasure! This is an 1897 photograph of six-month-old Frank Joseph Wehrli, father of Joyce Elizabeth Wehrli. Frank fathered 13 children, has 62 living grandchildren, 111 great-grandchildren, and 12 great great grandchildren. He lived from 1896 to 1947. Frank was the only son of Andrew and Eva Keller. (Courtesy of Joyce Elizabeth Wehrli.)

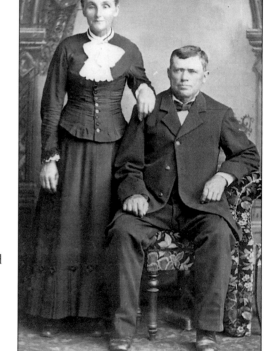

Joseph and Elizabeth Schmitt Wehrli arrived in Naperville in 1849. Born in Alsace/Lorraine, France, Joseph was the son of Anthony and Marie Herschell Wehrli. Elizabeth was the daughter of Martin and Anna Marie Pfaff Schmitt. (Courtesy of Joyce Elizabeth Wehrli.)

# Four

# SETTING THE STANDARD

## NAPERVILLE'S
## PUBLIC SAFETY TEAMS

*"Every brave man is a man of his word."*

—Corneille

*T*imes change. Today is the child of yesterday. The word "sheriff" was originally "shire-reeve," which became when spoken quickly, "sher iff." In ancient times it denoted the bailiff of the court of the county, then termed the "shire-gemote," or its meaning to the general people, "to do justice."

Minutes of the city's board meeting of May 12, 1876, tell us that a policeman was approved. He was to be paid $25 a month. One of his duties was to light and take care of the outside lamps. On March 17, 1890, the Village of Naperville became a city. The position of constable was renamed to police marshal.

The Village Council on May 4, 1857, passed an ordinance which formed fire companies and established water supplies. In 1870, Fire Marshall Willard Scott ordered that "the bells of the Evangelical Church be rung in case of fire." There are meeting records for some volunteer companies. The Joe Naper Engine Company was formed in 1874, and another Hose Company 1, "The Naperville," also formed bucket brigades when a conflagration threatened the city. From city council records we learn that an engine, hose cart, speaking trumpets, brooms, and 700 feet of hose had been purchased for $1,752.50. The year was 1874.

Modern DuPage County comprises both farmland and cities that peacefully coexist, ruled by social laws and customs. These two nationally recognized public safety institutions continue to provide crime prevention, emergency communications, fire safety protection, and many other community services.

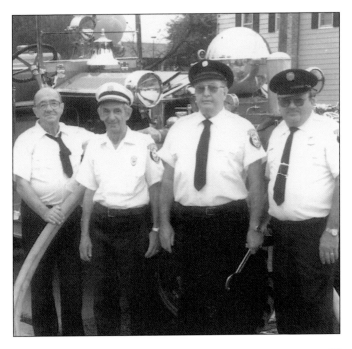

Paul Riedy, Joe Weigand, Ken Clark, and Bob Rudrich are pictured here on a festive summer day. They are probably getting ready to ride in the parade! (Courtesy of Joe Weigand.)

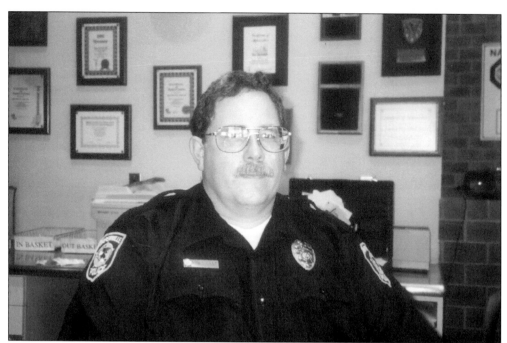

Police officer Dirk Wolgast, who joined the Naperville Police Force on January 9, 1984, is pictured at the new police station desk. There had been little mention of a formal police department from 1857 until 1913. In the early years, the police station was located on Jefferson Street, and the telephone number in the late 1920s was "261." The police chief received a monthly salary of $175. George G. Anderson was appointed the first chief of police in 1915. (Photograph by Jo Fredell Higgins.)

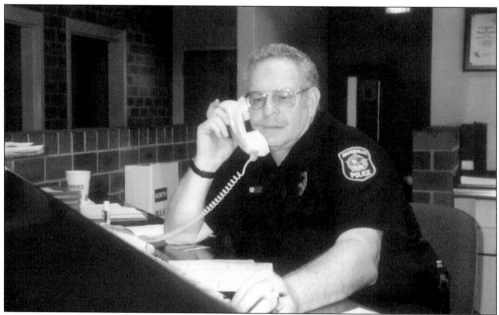

Police officer Robert Mair joined the Naperville Police Force on May 21, 1973. (Photograph by Jo Fredell Higgins.)

Naperville City Hall is shown here on Friday, April 27, 2001. The trees are resplendent with spring color and lend a certain nature's elegance to the building where Mayor A. George Pradel and the city council meet to conduct the city's business. (Photograph by Jo Fredell Higgins.)

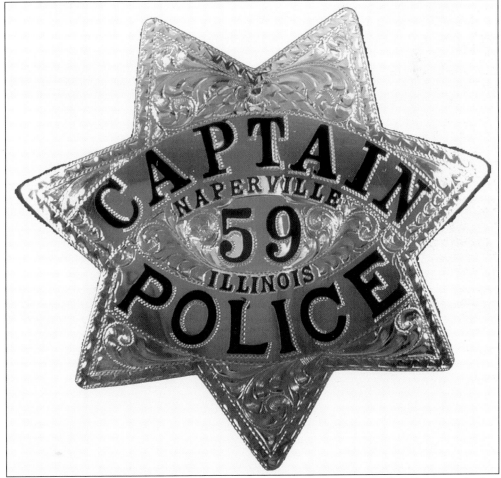

Police Captain Jon A. Ripsky wears a #59 badge for the City of Naperville. These new badges have been designed by the Ed Jones Company of California. Captain Ripsky has served 39 years! His father, Michael F.C. Ripsky, served also from 1941–1961. In 1941, there were eight policemen. Today there are 181 policemen and women. (Courtesy of Captain Jon A. Ripsky.)

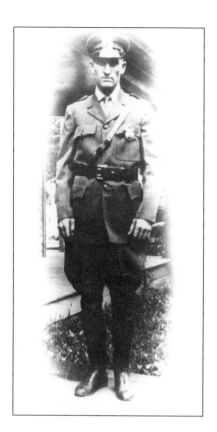

Chief of Police Robert Worthel was killed in the line of duty on September 24, 1927, in a motorcycle accident. This photograph was taken in 1927.

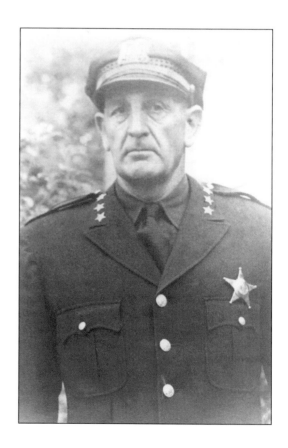

Chief of Police Eddie Otterpohl served from 1927–1953.

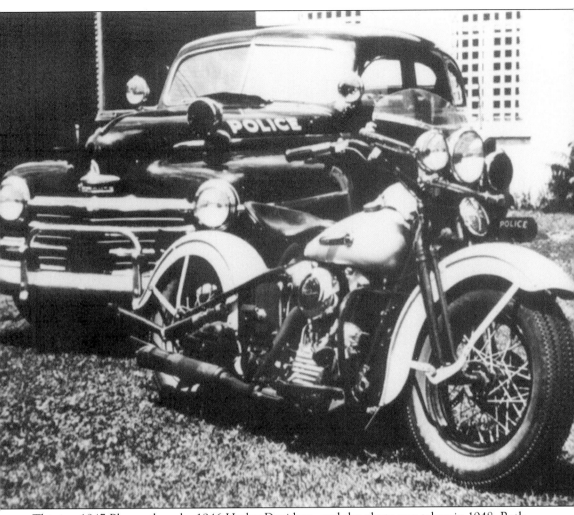

This is a 1947 Plymouth and a 1946 Harley Davidson, and the photo was taken in 1948. Both vehicles were in use at that time. (Courtesy of Captain Jon Ripsky.)

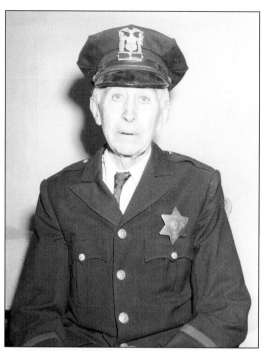

Chief of Police Edward Fairbanks served on the force from 1915–1927. (Courtesy of Captain Jon A. Ripsky.)

A normal night patrol is shown here going north on Washington at Jefferson Avenue in 1968. It was 3:00 a.m.

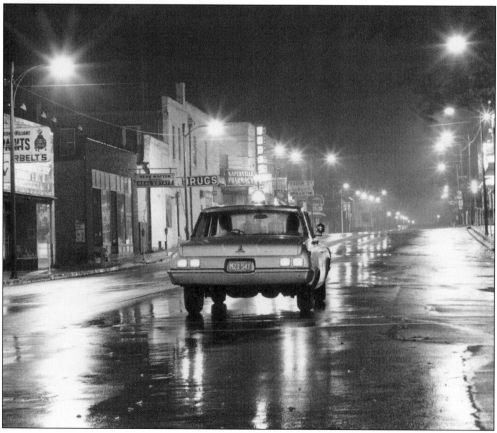

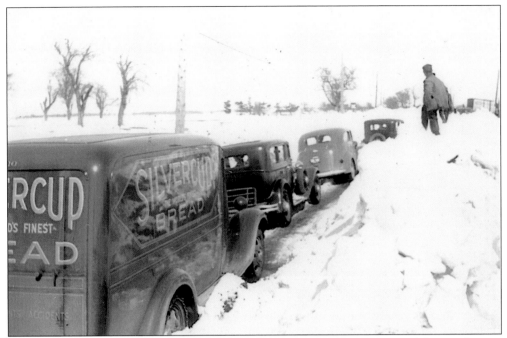

In 1938, snow blanketed the Fox Valley area, and at the northwest corner of Aurora Avenue and Route 59, this scene was captured on film. Its location was at Gregory's Farm. (Courtesy of Bill Schrader.)

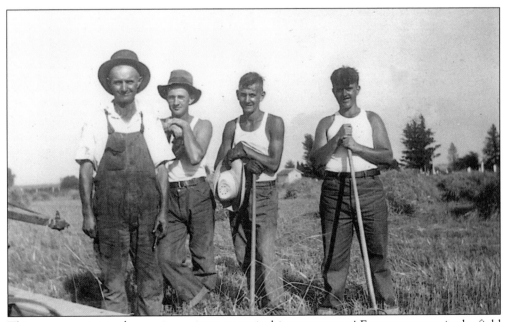

This counterpoint to the previous winter scene is this summer one! Four men pause in the field of the Robert Clow farm in 1932. They were Bob Clow Sr., Bob Clow Jr., Harry Clow, and Harold Schrader. (Courtesy of Bill Schrader.)

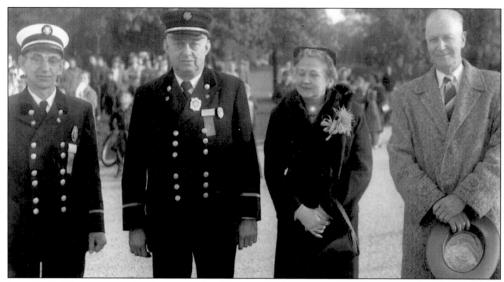

Joseph A. Weigand was the first paid chief fire marshal for the city from 1954 to 1965. He served a total of 33 years. His grandfather, B.V. Boechler, was the former chief before the 1900s. Joe was born on January 9, 1910, the third oldest child of Walter and Susan Weigand. "I remember when Main Street was paved in 1913," Joe began, "from Franklin down to the alley in back of Jefferson Avenue. There was a fire cistern on the corner of Main and Benton where we played as children. They tiled the creek by Main Street that went down to the river at the back of our house on North Main Street. Every time the fire whistle blew, we would run down to find out where the fire was." Fire Chief Joe Weigand, retired chief Chris Foucek, Mrs. Charles Foucek, and a representative of the governor of Illinois are posing for the camera, c. 1960. (Courtesy of Joe Weigand.)

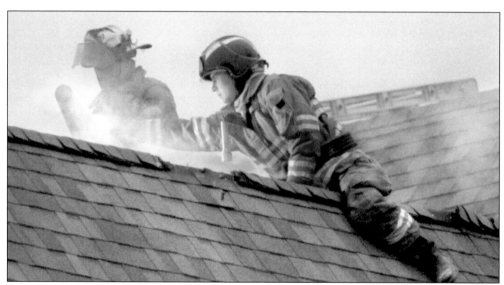

Pictured here is a firefighter on the roof of a home at 212 West Franklin Avenue, February 2000. There was $200,000 in damage. A passerby and a neighbor both dialed 911 to report fire and smoke coming from the house. Three fire engines, two ladder trucks, a heavy rescue squad, and two ambulances responded to this fire. (Courtesy of the *Naperville Sun*.)

This historic flood brought 17–20 inches of rain to the area. The Flood of 1996! (Courtesy of the *Naperville Sun*.)

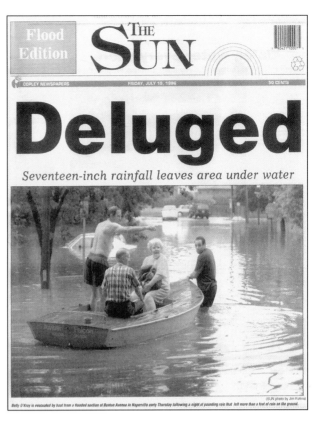

This is the original fire station at 126 West Jefferson Avenue. On December 19, 1874, Naperville's Village Council drafted an ordinance that all saloons "shall be closed at the sound of a fire alarm and shall remain closed until the emergency passed." A comprehensive ordinance was passed on January 2, 1875, that established and defined the fire department. (Courtesy of Joe Weigand.)

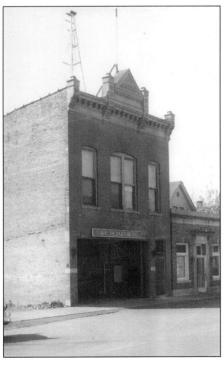

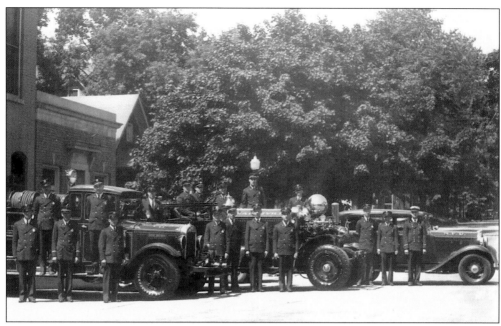

On May 30, 1936, the firemen posed for this photograph. It was a beautiful spring day. (Courtesy of Joe Weigand.)

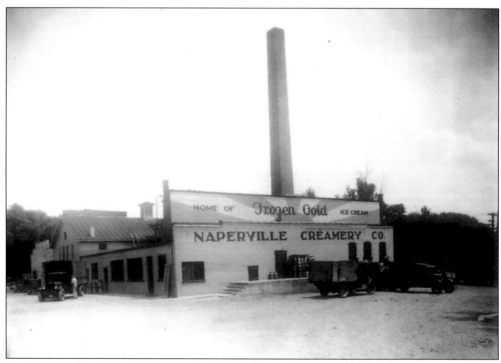

On January 28, 1936, the Prince Castle Ice Cream Company had a fire which had been hampered by frozen hydrants. The *Naperville Sun* reported that water had to be taken from the DuPage River. Approximately 650 feet of 2.5-inch hose was laid for this fire. (Courtesy of Rita Fredenhagen Harvard.)

This is a view of the Cock Robin
Ice Cream Company sign in 1967.
In 1960, Naperville comprised
about 1,724 acres. After annexations
of 1,596 acres that year, the city
almost doubled in size. This rapid
growth was to set the tone for
the next 30 years. (Courtesy of
Rita Fredenhagen Harvard.)

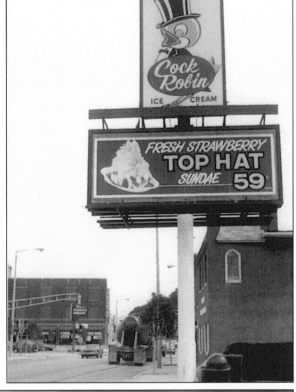

This is Les Brown's Furniture fire
in 1943. It was caused by a gas
explosion. The store was located at
219 Water Street. This was the only
major conflagration during the war
years. Again, on August 30,
1946, the factory, which had been
rebuilt, burned again and loss was
set at $30,000.

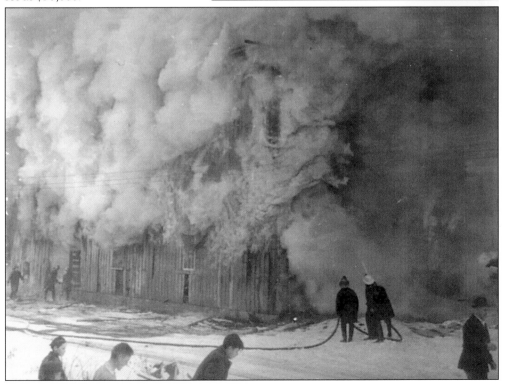

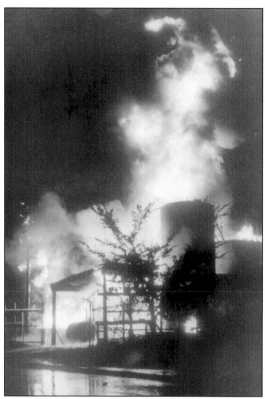

A fire was reported on August 20, 1964, at the Curran Oil building at Jackson Avenue and Ewing Street. Joseph Weigand was fire marshal at this time until his retirement the following year. (Courtesy of Joe Weigand.)

On Friday, September 13, 1946, the Moore Lumber Company burned. It had been established in 1909, and was a fixture on Main Street near Water Street for many years. The spectacular blaze was not extinguished until 10:45 p.m. that night. Loss was set at $20,000. (Courtesy of Joe Weigand.)

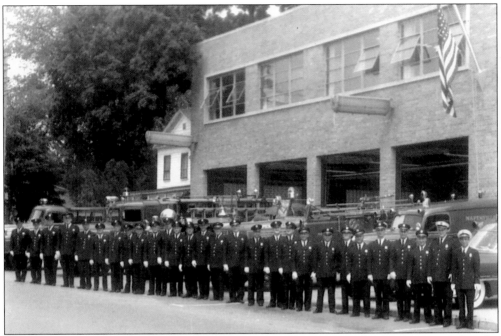

It is Memorial Day 1955, and several members of the fire department pose for the photographer. Notice the hook and ladders on the equipment. The men are not identified. (Courtesy of Joe Weigand.)

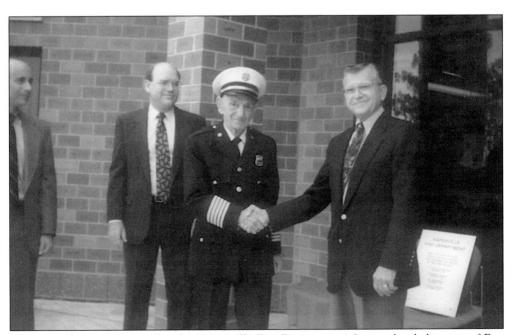

This was a happy occasion for the Naperville Fire Department! It was the dedication of Fire Station #7 at 1380 Aurora Avenue in 1992. Naperville's population was 85,806. Pictured here are Fire Marshall Joe Weigand and Mayor McCrane. (Courtesy of Joe Weigand.)

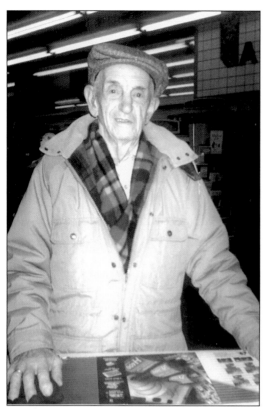

After retirement, Joe enjoyed his quiet life in Naperville. This is a candid shot of him c. 1984. (Courtesy of Joe Weigand.)

While visiting with Joe and his sister Rita in March 2001, I took a number of photos. Joe, who was 91 years young on this day, was a delight and full of the joy of living. Rita was a gracious host as she brought out more and more photos for me to choose from and offered me tea and cake. (Photograph by Jo Fredell Higgins.)

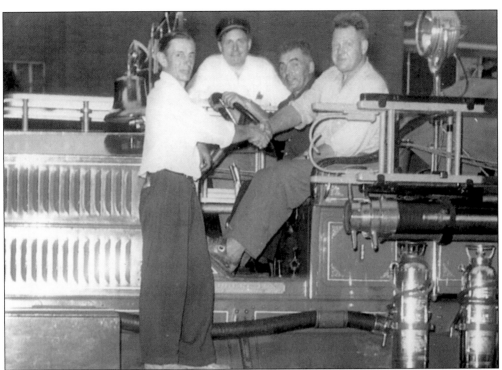
Pictured here is a casual pose by some unidentified firemen in 1954. (Courtesy of Joe Weigand.)

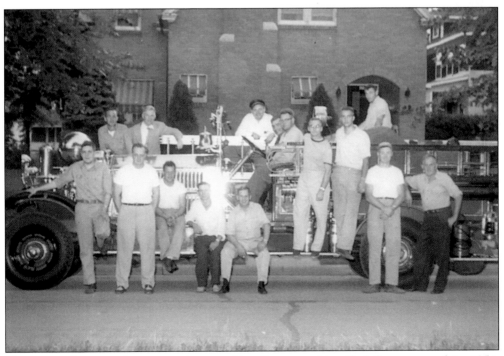
This is another casual picture taken outside of some unidentified fire personnel in 1954. (Courtesy of Joe Weigand.)

# OFFICIAL COMMISSION

*In the noble seafaring tradition of that Great Lakes sailor and shipbuilder Captain Joseph Naper, who founded our City in 1831, and by the authority vested in me by the people of Naperville, Illinois, the most famous port on the DuPage River, I hereby commission you*

### Joe Weigand

*as an*

## HONORARY CAPTAIN

*in the*

## NAPERVILLE NAVY

*and in recognition of your achievements, you are forever granted free docking privileges on the DuPage River at the Naperville Riverwalk and are further entitled to serve as a command officer on the covered bridge over the roaring DuPage and to be treated with all respect due to an Honorary Captain.*

MAYOR, CITY OF NAPERVILLE, ILLINOIS

*Dated this* 21st *day of* May *, 19* 82

# Five

# OVER TEA CUPS
## NAPERVILLE'S WOMAN'S CLUB

*"She became for me an island of light, fun, wisdom where I could run with my discoveries
and find welcome."*

—May Sarton

Twelve women of Naperville met over teacups on February 22, 1897, at the home of Mrs. Willard Scott to consider organization of a literary club. Their objectives included "the study of history and literature and also the general intellectual and social culture of its members." Early programs included lengthy historical papers that dealt with literature in the 17th century or Queen Elizabeth or the customs and language of France. During the years of World War I, activities included national defense, children's health issues, food conservation, and first aid classes. Three French war orphans were adopted, and liberty bonds were purchased. Annual dues were set at $1, but some felt that too high. "Excuse me, but some of us cannot ask our husbands for an extra dollar, all at one time," protested one member. It was then determined that the fee, equivalent to $82 in 1997, would be paid on a quarterly basis.

In l900, funds were raised to donate to the Nichols Library. By 1912, they were raising money for the flood victims in Indiana and Ohio. About 1920, a tree was planted in Burlington Park in remembrance of the men and boys who lost their lives in WWI.

This club donates to many local organizations including the Indian Scholarship Fund, the Bethlehem Center Food Bank, Hesed House, Little Friends, and St. Patrick's Residence. They have also donated to Safety Town, the Shawnee National Forest, and have sponsored several educational scholarships.

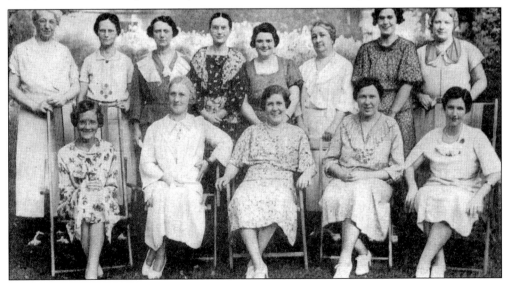

These are the original minutes handwritten from the Naperville Woman's Club, 1907.

The former German Congregational Church was built by German immigrants in 1900, and purchased by the woman's club in 1925. The cost was $3,500. This photograph was taken on a lovely spring day in May 2001. (Photograph by Jo Fredell Higgins.)

In 1922, the Woman's Club Chorus sang for the first time under the direction of Mrs. Walter Fredenhagen. This is the chorus about 1936. (Courtesy of Marilyn McKay.)

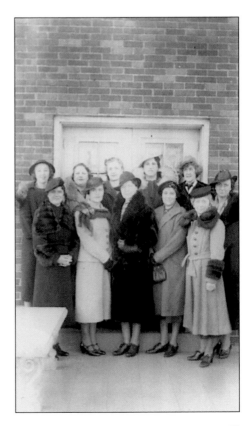

Pictured here are unidentified Woman's Club officers for the 1937–38 season. (Courtesy of Marilyn McKay.)

In March 1997, the women wore long skirts, high-necked blouses with brooches at the collars, flowered hats, and silk gloves to celebrate their 100th anniversary. The original gathering was recreated in a skit based on the minutes of that first gathering and performed by club members. Pictured here, from left to right, are: Barbara Walsh, Tina Noun, Jo Dagenais, and Judy Barnett as cast members for this auspicious occasion. (Courtesy of Marilyn McKay.)

Unidentified Woman's Club members stand by the refreshment table for the "Welcome Back Tea" in September 1996. (Courtesy of Marilyn McKay and the Naperville Woman's Club archives.)

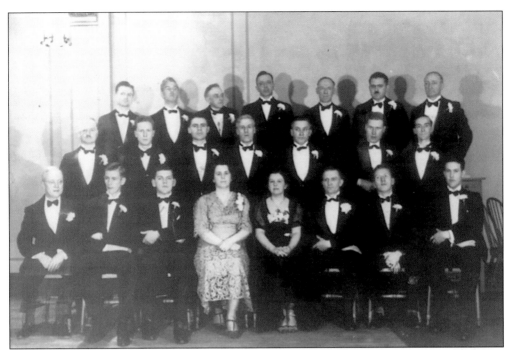

The Naperville Male Chorus with Mildred Milton Stauffer and Grace Towsley Fredenhagen (Director) is pictured about 1935. (Courtesy of Rita Fredenhagen Harvard.)

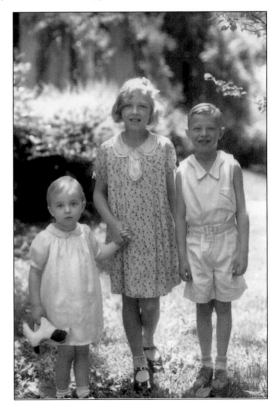

"Who will buy this wonderful morning? What a day I never did see," are the fetching lyrics of the well-known song from *Oliver*, the book, music, and lyrics written by Lionel Bart. Rita Fredenhagen Harvard, Jeanne Fredenhagen Moen, and brother W.S. "Ted" Fredenhagen take a stroll on such a day in 1932. (Courtesy of Rita Fredenhagen Harvard.)

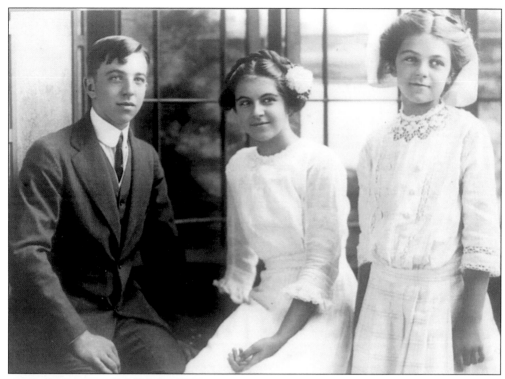

Myron Towsley, Grace Towsley Fredenhagen, and Charlotte Towsley Scofield pause on a early June day in 1911. They may have been expecting new furniture to be delivered for the dining room! It was the year that Oliver and Arthur Beidelman began their furniture and undertaking business from Fred Long, who had founded it in 1861. Enrolled in Naperville's student body at that time were 117 high-schoolers and 410 grade-schoolers. (Courtesy of Rita Fredenhagen Harvard.)

Grace Towsley Fredenhagen, Myron Towsley, and Charlotte Towsley Scofield were captured on film in this jocular pose in 1918. Myron was on leave and arrived home in Naperville to see his sisters as well as other family members. (Courtesy of Rita Fredenhagen Harvard.)

Walter Scott Fredenhagen, age 20, looks so handsome and professional in this 1915 photograph. (Courtesy of Rita Fredenhagen Harvard.)

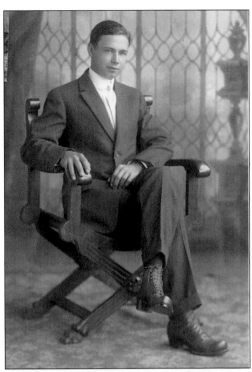

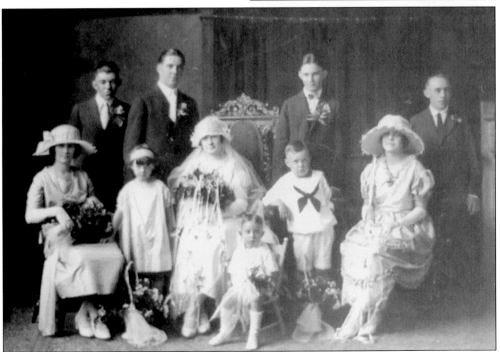

Marie Hill and Leo Hiltenbrand's wedding is shown here in 1923. Pictured from left to right are: (seated) Francis Hill, unknown, Marie Hill, Carl Barenbrugge, Bob Wehrli, Bernadine Hiltenbrand; (standing) August Hiltenbrand, Leo Hiltenbrand, and unknown. (Courtesy of Joyce Elizabeth Wehrli.)

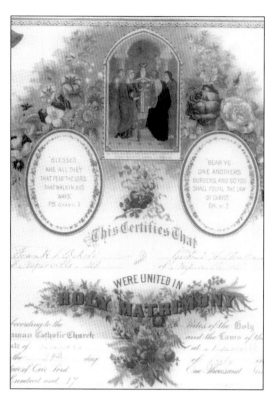

Pictured is the marriage certificate of Frank Wehrli and Gertrude Hiltenbrand July 24, 1917. (Courtesy of Joyce Elizabeth Wehrli.)

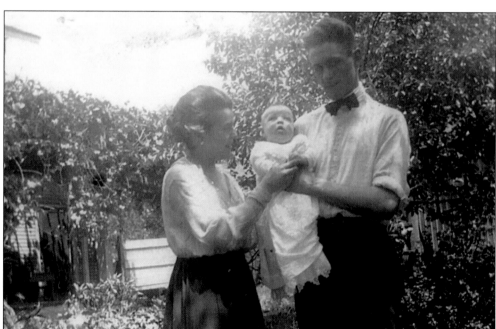

Gertrude Hiltenbrand and Frank Joseph Wehrli are pictured at 154 North Center Street, Naperville, with baby Robert in May 1918. We recall what Emerson wrote that "Every spirit builds itself a house. . . ." What a wonderful home and family life they established before Frank died in 1947, and Gertrude died in 1974. (Courtesy of Joyce Elizabeth Wehrli.)

# *Six*

# OF BETROTHALS AND HOMEMAKING

*"But happy they, the happiest of their kind, whom gentle stars unite and in one fate their hearts, their fortunes and their beings blend."*

—Thomson

Social life during the times of settlement in Naperville was centered on family activities. Cooperative help was needed for log rollings, house building, quilting, or harvesting.

Threshing took at least a dozen men working together. The machines were coal-fired and belched black smoke. Grain was separated, and the straw and the chaff were blown into huge piles. . . much to the delight of the farm kids. Such gatherings brought gaiety and dancing was usual for the younger family members.

The men enjoyed athletic games and contests that involved racing or jumping or wrestling. Women put up the potatoes, melons, and pies. And they sewed the curtains for the newly raised cabin home. When they dressed for a special occasion, they looked resplendent in gossamer whites. In those days, it took from 12 to 15 yards of material to make a dress of sufficient length to sweep the walks, for the high necks and long sleeves, for the breadth required for the hoop skirt and bustle, flounces and ruffles. Women could be quite natty in appearance with an appropriate chapeaux.

With the turn of the 20th century, a wedding was the social occasion. Gifts to the bridal couple could include silk scarves, cut-glass dishes, nutcracker bowls and picks, the Bible, velvet pincushions, orange spoons, silver cake servers, or pudding dishes. Fine linens and nickel-plated flat irons were also in vogue. Today's couple would request food processors, computer-related items, battery-powdered toys and games, and home appliances. Homemaking is significantly easier and faster for today's betrothed couple.

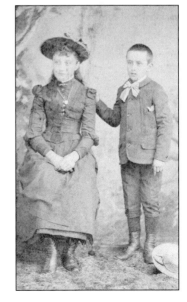

Emma and William Scherer pose in 1883, for Kendig Photographer in Naperville. It would be five more years before an infant motion picture camera and George Eastman's "Kodak" box camera would be introduced. This decade saw the inventions of Thomas Edison's incandescent lamp, electric trolley cars, the fountain pen, malted milkshakes, Petrol engines, steam turbines, and long distance telephone lines. There was a 17% illiteracy rate in the United States, with a population of just over 50 million souls. In Naperville, roller skating was a recreational pastime. Ladies could skate for 10¢, and men paid 15¢. Central Park had a bandstand where the Naperville Light Guard Band played. In 1885, the first public telephone would be installed on Jefferson Street in Tom Saylor's store. Ed Dieter had a switchboard in his drug store. In 1886, George Reuss opened a private bank. Naperville would soon complete its city hall as the decade was ending. It was built by J.W. Baumgartner for $435 and designed by J. Mulvey for $25. (Courtesy of Dyonne Brys.)

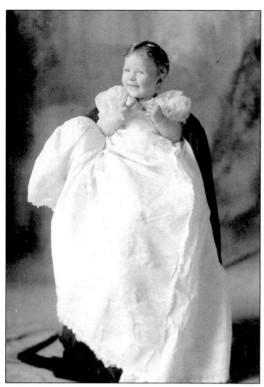

Pearl Mertz is pictured in 1902, at about six months of age. Naperville at this time had a modern lighting plant, and DuPage County land was selling for $100 an acre. In 1903, Peter Kroehler, an 1892 graduate of North Central College, became president of the Naperville Lounge Company. Also in 1903, the city made plans for a waterworks system. (Courtesy of Dyonne Brys.)

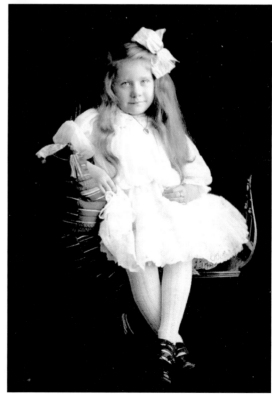

This glorious photo of Pearl Mertz was taken to celebrate her fourth birthday on December 25, 1905. What a stunning dress and beautiful little girl! (Courtesy of Dyonne Brys.)

Pearl Mertz is shown wearing a fashionable hat in 1922. Its pouf of ribbon was all the style then. Women's hats usually had lace, ribbons, bouquets of flowers, and bunches of fruit to adorn them. In 1905, the Sears, Roebuck catalogue featured some 75 versions of ostrich feathers. Other adornments might have been purple grackles or red-winged blackbirds, orioles or skylarks, pigeons or doves, thrushes or wrens. The Audubon Society had tried in 1900 to halt the sale of such plumage and did so in vain. (Courtesy of Dyonne Brys.)

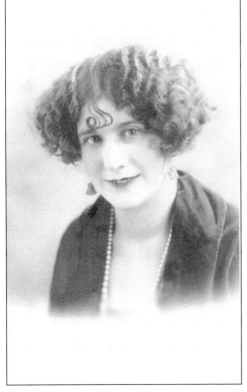

Pearl Mertz is depicted with delightful wavy hair in 1920. According to her niece, Dyonne Brys, Pearl was the vamp—the fun-loving and sassy young woman. She loved attention and enjoyed life thoroughly. She could have taken tea with friends at the Spanish Tea Room with its romantic Spanish atmosphere. Pearl was the epitome of the Roaring Twenties flapper girl with flirtation and flair. I wish I had known her! (Courtesy of Dyonne Brys.)

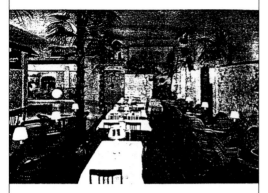

GRANADA GARDENS

ROMANTIC SPANISH ATMOSPHERE

*It Fascinates*

« « o » »

# THE SPANISH TEA ROOM

« « o » »

31 College Employees in 1932

CLARENCE CROFT     EDGAR CROFT     HAROLD CROFT

A legendary restaurant and dining establishment opened in 1925 at 126 South Washington Street. The Spanish Tea Room had a fountain and fish pond, patio and balcony, sizzling steak and turkey dinners, clover-leaf rolls, and homemade pies. Luncheons began at 25¢, and chicken dinners were 60¢. On Saturday nights, the Orrin Tucker orchestra played. Most waiters were North Central College students. Helen Dewar Norton was quoted in the book *Sky Lines* that, "tips were good on weekends, even in the Depression. I made $13 one holiday, I remember." In November 1936, the Spanish Tea Room closed, a casualty of the Depression and continued hard times.

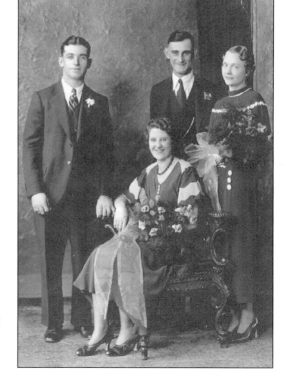

Pearl Mertz Knippen is pictured on her wedding day to Frank Knippen. The date was October 6, 1934. Pictured from left to right are: Frank Knippen, Pearl (seated), brother Norris Mertz, and his wife Katie Mertz. (Courtesy of Dyonne Brys.)

This beautiful bride was Emma Scherer Mertz as she posed for her formal portrait on April 9, 1901. The population of Naperville was 2,600. She might have driven to the ceremony in a "horseless carriage." (Courtesy of Dyonne Brys.)

These two photos of William and his wife, Elsie Scherer, were taken in the 1920s. William worked at the Scherer Hardware store in downtown Naperville.

They could have stopped in to Wilson's Café to enjoy an afternoon crumpet or scone, or Oswald's Drugstore for combs or confections. The Pre-emption House could have put up their wedding guests for the occasion. (Courtesy of Dyonne Brys.)

Solomon Mertz is pictured on his 500-acre farmland, which he later sold to the Morton Arboretum. The year was 1887. Solomon had lived in Lisle in 1844, and moved to Naperville in 1870. He was the father of 20 children by two wives! Solomon was born in Allentown, Lehigh City, Pennsylvania, and emigrated to Naperville in 1846, with his first wife, Lucy Butts, and seven of their eleven children. After her death in 1854, he married Salome Rehm of Durrenentzen, Alsace, and had nine more children. His home in Naperville was situated where the present Nichols Library is located. (Courtesy of Dyonne Brys.)

Two sons of Solomon Mertz are pictured here in the 1940s. George Mertz is on the left, and Edward Mertz is on the right in this photo. The population in Naperville is 5,280. City council members met with the Association of Commerce to discuss solutions to the growing parking problems in downtown. Some things, it seems, never change! (Courtesy of Dyonne Brys.)

Pictured from left to right are: Elizabeth Kampmeyer Harris, Ralph Kampmeyer, and Marjorie Kampmeyer Meyer. They sat for the camera during the polio epidemic of 1920. Many families took photos of their children at this time due to the real fear that they might take the disease and die. (Courtesy of Mary Ann Bobosky.)

This young woman's photo was shot at the M. Melander and Bros. Studio in Chicago located at 208 East Ohio Street. Her white frock was completed with white satin shoes so popular in the 1930s. Her name is unknown. (Courtesy of Jo Fredell Higgins.)

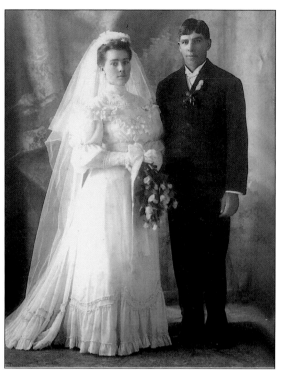

This is the wedding photo of Ann Riedy Meyer and David Meyer. The ceremony took place at SS Peter and Paul Church in Naperville on September 27, 1905. (Courtesy of Brand and Mary Ann Bobosky.)

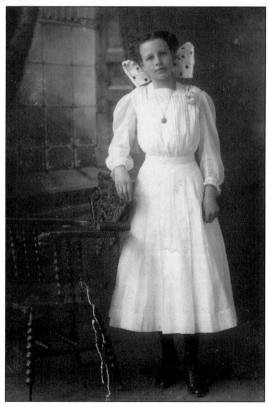

An unidentified young woman poses for the camera about 1926. (Courtesy of Jo Fredell Higgins.)

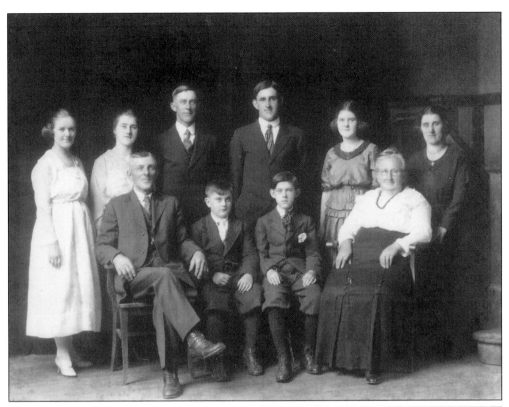

The Charles Schrader family is pictured here. Standing are Mabel Schrader Binder Tholin, Grace Schrader Brady, George Schrader, Peter Schrader, Clara Schrader Stark, Ella Schrader Boldt, and seated are Charles Schrader, Harold Schrader, Lester Schrader, and Sophia Fluegge Schrader. Charles was born in the Copenhagen area, south of Naperville. Sophia was born between the forks of the DuPage River. The older children were born in DuPage Township. The last family farm was located on Schmidt Road just west of Bolingbrook. House. Barn buildings still are standing. Charles and Sophia moved to Webster Street near the future Naper Settlement. This photo is c. 1917. (Courtesy of Clarita Boldt.)

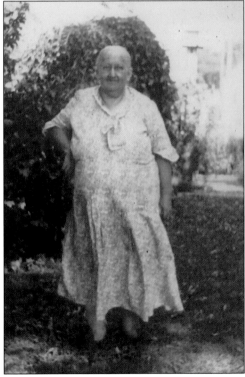

Grandma Sophia Schrader is pictured in 1940 at her home at 554 South Webster Street, Naperville. Sophia bore 11 children. (Courtesy of Mary Schrader and son Bill Schrader.)

Two delightful children are captured on film in 1941, in the backyard of the house at 540 South Webster. They are Carol Lee Schrader Cole and brother Bob Schrader. (Courtesy of Mary Schrader and son Bill Schrader.)

Carol Lee Schrader Cole and her friend smile during the Sunday school picnic on the Fourth of July 1942. (Courtesy of Mary Schrader and son Bill Schrader.)

Cecil Stark Mitchler, Inez Stark Holmgrem, Mary Lou Schrader Collins, and baby Carol Lee Schrader Cole are pictured in their backyard about 1936. (Courtesy of Mary Schrader and son Bill Schrader.)

H.B. Homer Grommon is shown holding Sarah Hortense Webster in 1921, near 104th Street and South Book Road. Naperville Country Club had purchased land to build a golf course. Naperville City Council voted to adopt Daylight Savings Time, as the City of Chicago had already implemented. An amateur radio group, the Radio Club, was formed in 1921. (Courtesy of Mary Schrader and son Bill Schrader.)

Shown here is an unknown young woman posing in the sunlight near Centennial Beach, c. 1940s. (Courtesy of Mary Schrader and son Bill Schrader.)

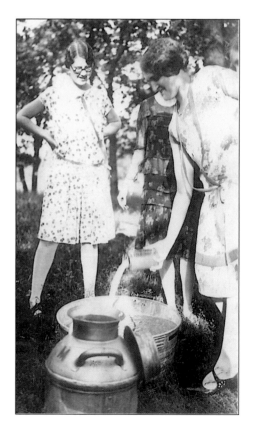

Unknown young women are making lemonade at a social function in Naperville, c. 1940s. Developments in Naperville included installation of parking meters, which cost 10¢ for two hours. Helicopter mail service linked Naperville and 29 other suburban towns with the Chicago Municipal Airport, later named Midway, and in 1946, Argonne National Laboratory was built in DuPage County. (Courtesy of Mary Schrader and son Bill Schrader.)

# Seven

# NAPERVILLE SCHOOLS AND CHURCHES

*"The education of the human mind commences in the cradle."*

—T.Cogan

The date was December 1832. In a log schoolhouse, Mr. Strong, teacher, faced his class of 22 students. Captain Naper, Bailey Hobson, and Christopher Paine were supervisors. In 1835, a frame schoolhouse was erected. A year later, Lewis Ellsworth bought several hundred acres and built a home at the location of the abandoned Fort Payne. His wife's niece started a private school for 12 young ladies who learned "modern language," music, drawing, and painting. By 1843, Hobson School was built at a cost of $97.26. The teachers received $10 for the eight-week sessions. By the mid-1850s, Naperville had "five large schools, which were well attended." In 1857, there were six churches, two hotels, 12 stores, one bakery, one bank, two post offices, one gristmill, one sawmill, and 10 manufacturers.

Three churches were established in the first decade of settlement. There were the First Congregational Church, the First Methodist Church, and the Evangelical Church. Between 1840–1850, Catholic families were ministered to monthly by traveling priests who came from Joliet to hold worship in a home. Saints Peter and Paul Parish was built in 1846. In 1855, a small school began. The Baptist church was organized by Rev. Morgan Edwards in 1843. He had nine members.

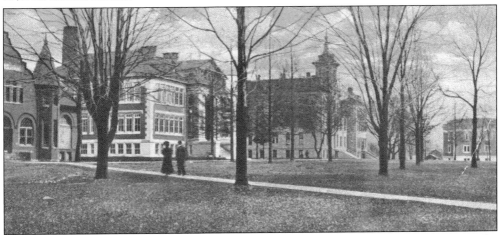

Old Main was built of limestone quarried in Naperville and is the oldest structure on the campus. On May 17, 1870, the cornerstone was laid. The editor of *The Naperville Clarion*, David Givler, wrote that "Never, within our recollection, have the prospects of Naperville been more flattering than at present. We ascribe much of this. . . to the locating of the N.W. College in our city." (Courtesy of Pat Sabin.)

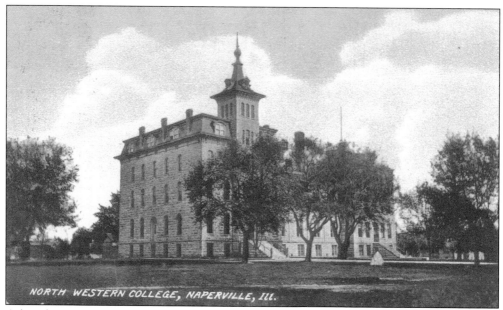

NORTH WESTERN COLLEGE, NAPERVILLE, ILL.

A bucolic campus was situated on 8 acres of land that had been donated by Delcar Sleight. Naperville residents had pledged $25,000 to bring the college to Naperville. The Naper, Hobson, Scott, and Paine families provided leadership for this community. Naperville had become an important hub in the transport of surplus grain, cattle, and sheep driven into Chicago. When the Chicago, Burlington & Quincy Railroad laid tracks in 1864, the town was on its way to becoming an important city. (Courtesy of Pat Sabin.)

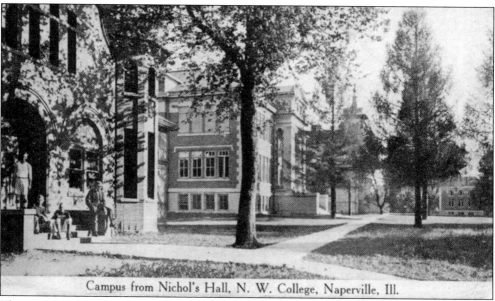

Campus from Nichol's Hall, N. W. College, Naperville, Ill.

This view of the campus and Nichol's Hall was taken in 1913. James L. Nichols lived from 1851–1895. In 1876, he had enrolled at the college with $1,000 in savings and graduated four years later only $65 in debt. He was a teacher and publisher until his death at age 44. In his will Nichols left $10,000 each for the construction of a free public library in Naperville and for the gym. The gym was destroyed by fire in 1929. (Courtesy of Pat Sabin.)

This 1979 view of Old Main with a full moon overhead is quite striking. It reminds us of the history of its dedication on October 4, 1870. Then it was written in *The Naperville Clarion* that "at least 1,000 people came to the ceremonies. Teams from the country brought loads of human freight, the railroad train brought others." Nearly $2,000 was collected that day for the college building fund. (Courtesy of Bill Gommel, The Picture Man, Inc.)

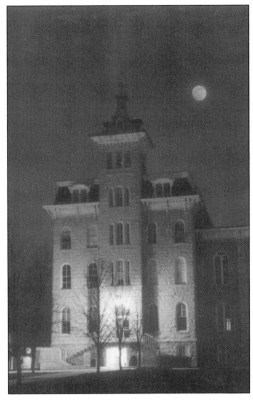

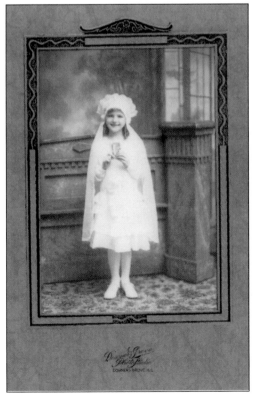

Cecelia Zolvinski Blazevich took her First Communion in 1933, at SS Peter and Paul Catholic Church in Naperville, Illinois. Father F.J. Rausch was the pastor. The school hall had been used as the church for almost five years until the altar and communion rail were moved to the unfinished church in November 1926. The pews arrived just before Christmas. The parishioners were souls of deep faith who met in this house of prayer to share both life's joys and sorrows. (Courtesy of Rita Fredenhagen Harvard.)

85

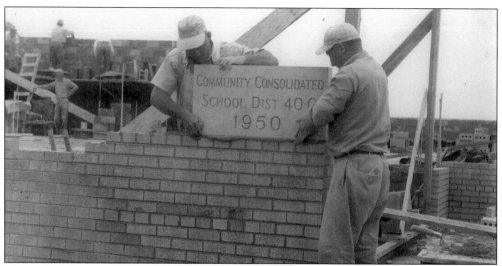

Masons set the cornerstone of the new Community Consolidated School District 40-C, one of three school districts which joined together to form Indian Prairie District #204 in 1972. Education was now more than one room with a fixed row of desks. Technology and newer teaching methodologies added to the cost of public education but also prepared students for the "information age."

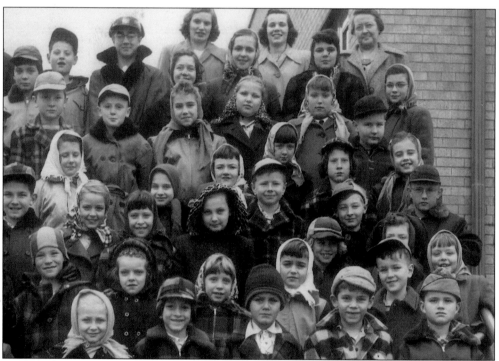

Pictured here are some of the first students who attended Wheatland Elementary School, c. 1950. Naperville had grown rapidly with easy access to Chicago by highway and train. New subdivisions would push the city into greater expansion. Moser's Forest Preserve subdivision started in 1950. Moser Highlands opened in 1951. In the next three decades, the population would increase by 508%. (Courtesy of Indian Plains District #204.)

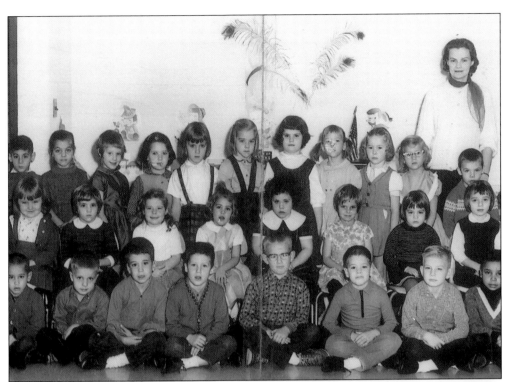

The sweet faces of these Indian Plains kindergarten children suggest that 1972 was an auspicious time! Members of this class were the first to go through the school district and graduate from Waubonsie Valley High School. The national women's rights movement would lead to the implementation in 1975 of new regulations resulting from Title IX of the 1972 Education Amendments. Title IX was designed to bring equality to the treatment of females and males in schools and colleges. For instance, physical education was to become coeducational except for rough contact sports. (Courtesy of Indian Plains District #204.)

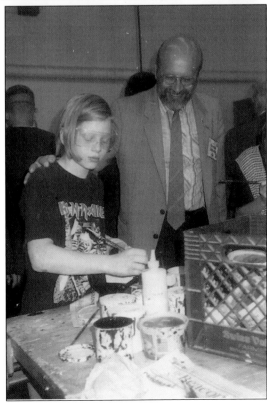

The paint brushes are wet as a student at Gregory Middle School shows a teacher from Nitra, Slovakia, her design. Members of the contingency from Nitra visited with students in May 1994, as part of the Sister City program with Naperville, which had begun in 1993. (Photo courtesy of Indian Plains District #204.)

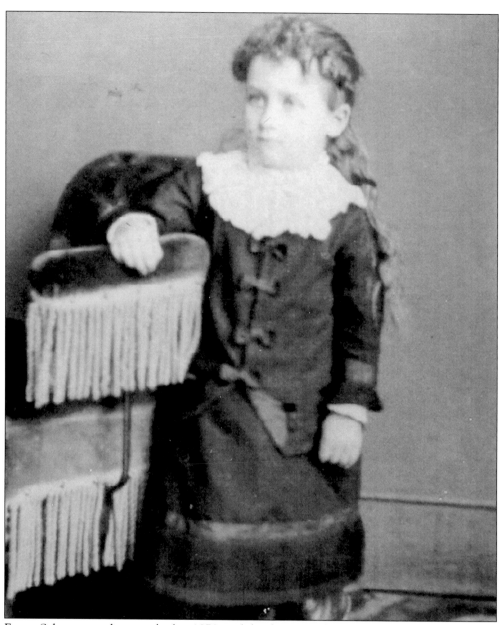

Emma Scherer was photographed in 1878, with her best satin bows and taffeta dress. Emma was about two years old. She might have attended Naper Academy, as it opened in 1852. Hannah Ditzler Alspaugh, student and later teacher at the school, wrote that during the summer of 1857, "the upper south room was divided into sleeping rooms for the Richmond boarders. The preceptress, Miss Dewey, had a room there. She presided in the evening when the pupils studied." By 1859, Mr. Richmond had financial troubles. The stockholders had presented him a note for $800 due. There was no money to cover this, and the building was offered for sale "for a sum not to exceed $2,500." The academy building was purchased by School District 78 in 1860, and was used for a public school until it was razed in 1928. A special charter obtained in 1863 is still valid. The board receives the funds directly from the County Collector and the County Superintendent. (Courtesy of Dyonne Brys.)

Shown here is a beautiful wedding pose of Valentine Bauer and Catherine Baier, taken in 1901.

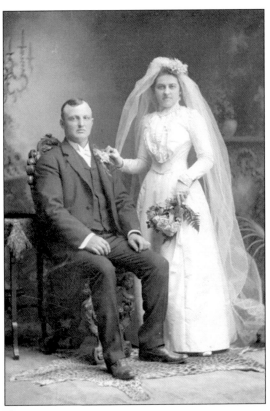

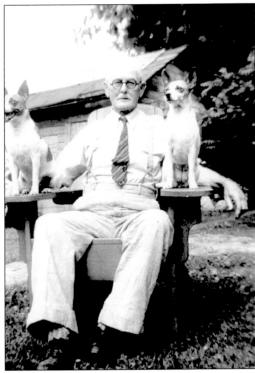

Grandpa Edward Mertz is pictured in his chair with pet dogs Molly and Mitzi, c. 1940s. (Courtesy of Dyonne Brys.)

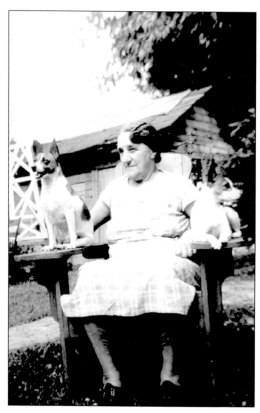

Grandma Emma Scherer Mertz is shown with pet dogs Molly and Mitzi, c. 1940s. (Courtesy of Dyonne Brys.)

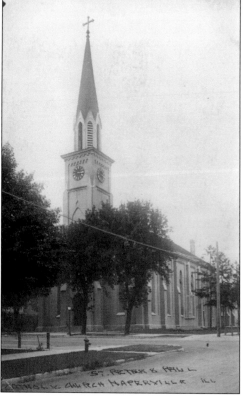

Two views (right and opposite top) of SS Peter and Paul Church are shown here. The original structure is shown, which burned to the ground in the early hours of Pentecost Sunday, June 4, 1944. Pastor Rev. B.J. Schuette opened the church door as flames had already developed into a roaring furnace. Nothing from the main building could be saved. The newer church postcard shows the building that was begun in May 1925. Its cost was better than $300,000. The cornerstone was laid by Rt. Rev. Msgr. Francis Rempe on Sunday, August 9, 1925.

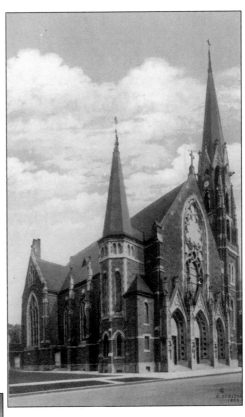

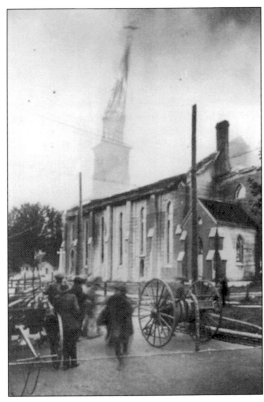

Shown here in all its devastation was what remained following the June 4, 1922, fire at SS Peter and Paul Church in Naperville, Illinois. (Courtesy of Jim Bauer.)

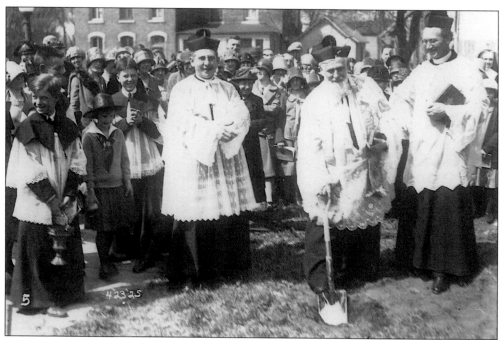

Fr. B.J. Schuette is shown in the middle of this photo with the shovel as he breaks ground for the new SS Peter and Paul Church. The date was August 9, 1925. (Courtesy of Joe Weigand.)

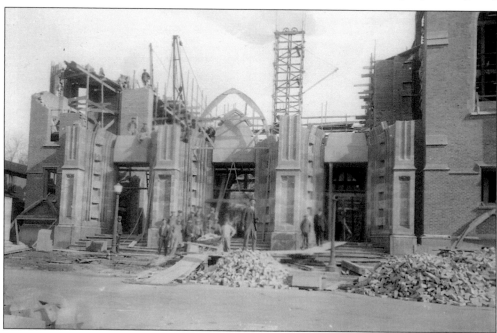

With a renewed spirit, the parishioners of SS Peter and Paul Church watched as the excavator began to dig the trenches for tunnels and foundation walls. It would take two years of intense work to complete the new edifice. Picnics and socials were organized with great success to help defray the cost of the new church. There were 350 families in the congregation at that time. (Courtesy of Joe Weigand.)

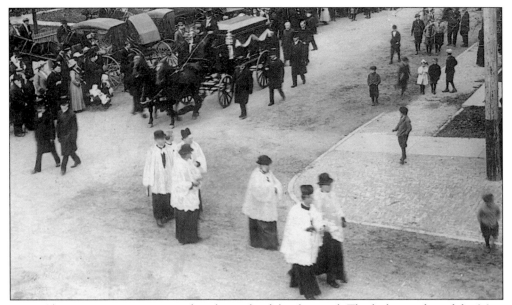

It is a Christian practice to remember the souls of the departed. The holy sacrifice of the Mass promotes piety and calls forth many prayers for the loved one. Here is a somber yet glorious scene of the funeral of Rev. Wenker of SS Peter and Paul Church, taken in 1911. Black top hats, coats, and dresses reflected the mood of the occasion as the cortege moved slowly to the church. (Courtesy of Joe Weigand.)

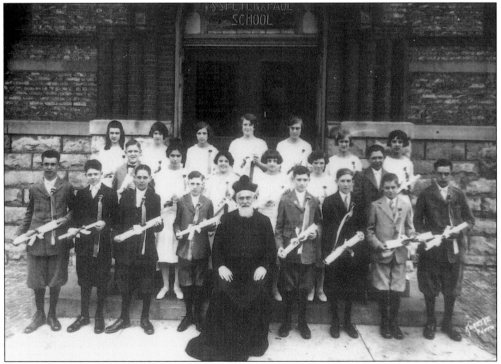

SS Peter and Paul School graduated the class of 1923, and posed for this group photo. Joe Weigand is next to the seated priest, Father B.J. Schuette. (Courtesy of Joe Weigand.)

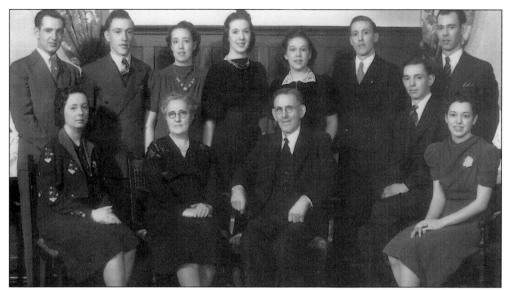

The family of Walter and Susan Weigand are seen in this early 1940s photograph. Joe is resting on the chair arm on the far right, beside his seated sister. Walter was a self-employed cement contractor and bricklayer. The census listed him as a "stone mason."

Walter laid the stones for the bathhouse at Centennial Beach in Naperville. He built the water tower by the nursery, and worked on the Episcopal church building where Aurora Avenue and West Street meet. He built many of the brick homes still beautiful today in the city. He died of natural causes at age 97, still enjoying his cigars! Susan died from cancer at age 68. Walter never remarried after Susan's death. (Courtesy of Joe Weigand.)

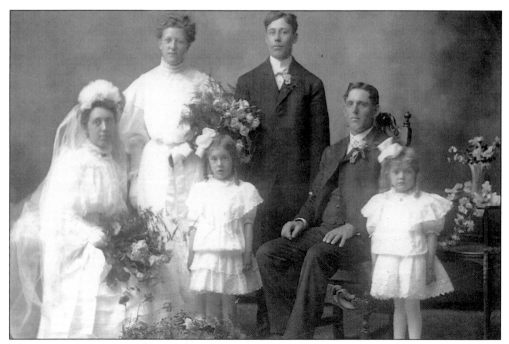

This is a fantastic wedding photo of Walter and Susan Weigand, 1906. (Courtesy of Clarita Boldt.)

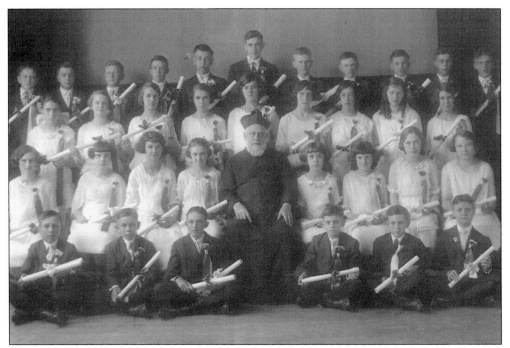

Father B.J. Schuette sits with the 1922 graduating class at SS Peter and Paul School in 1922. Gertrude Weigand Bauer is seated in the second row, third from the right. (Courtesy of Joe Weigand.)

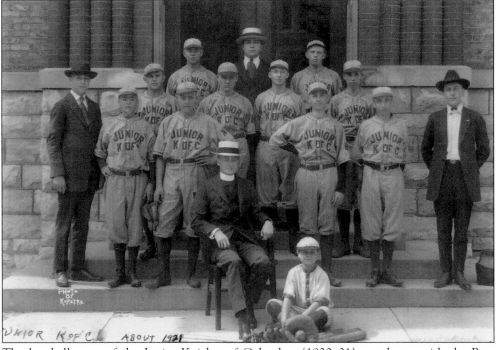

The baseball team of the Junior Knights of Columbus (1920–21) are shown with the Rev. Hermabn Ezel and Mascot Vince Schwartz. (Courtesy of Joe Weigand.)

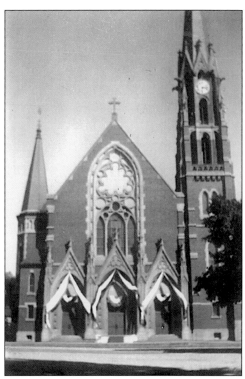

Pictured here is a 1939 view of the SS Peter and Paul Church with colorful bunting at the doorways. (Courtesy of Joe Weigand.)

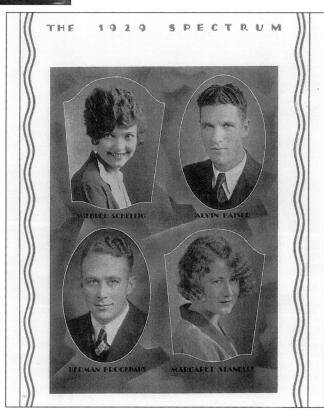

This image comes from the North Central College yearbook, "The Spectrum," c. 1929. (Courtesy of Ray Kinney.)

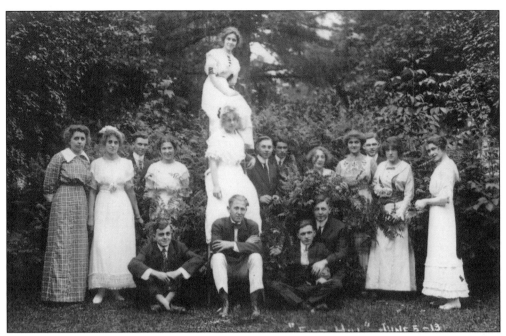

This postcard shows a group of North Central College students at Fort Hill in June 1913. This area was a picnic/recreation area where students could enjoy their Sunday afternoons. Later, it was purchased by the college, and residence halls were built. (Courtesy of the North Central College archives.)

Aunt Mary Patterson Perry and Marie Gocher visit on the porch, c. 1930s. What a beautiful portrait of two summer maidens enjoying their reading. Probably ice cold lemonade and ham sandwiches were ready for their lunch. Had they baked chocolate chip cookies for the dessert? (Courtesy of North Central College archives.)

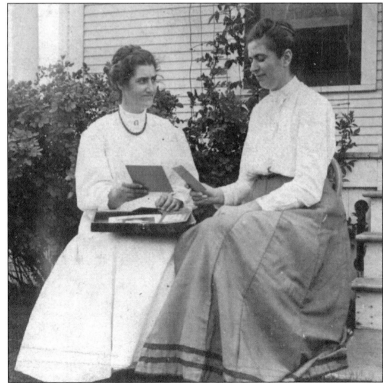

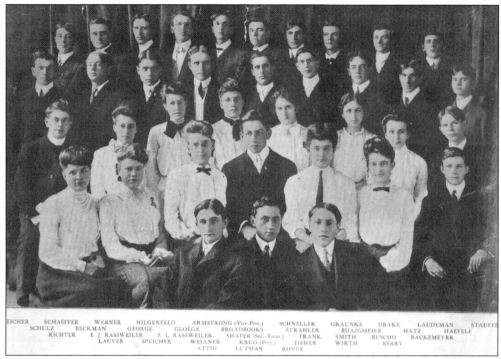

EICHER  SCHAEFFER  WERNER  HILGENFELD  ARMSTRONG (Vice-Pres.)  SCHNELLER  GRAUNKE  DRAKE  LAUDEMAN  STAUFFE
SCHULZ  BECKMAN  GEORGE  GLOEGE  BROADBOOKS  STRAHLER  BILLIGMEIER  HATZ  HAEFELE
RICHTER  E. J. RASSWEILER  E. L. RASSWEILER  SHAFER (Sec.-Treas.)  FRANK  SMITH  BUSCHO  BACKEMEYER
LAUVER  SPEICHER  WELLNER  KRUG (Pres.)  FISHER  WIRTH  BERRY
ATTIG  LUTMAN  ROYCE

Mr. Krug was president of his North Central College class, graduating in 1908. He composed the class song. (Courtesy of North Central College archives.)

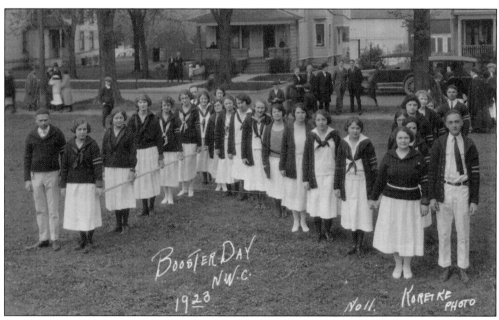

A marvelous visual treat! Northwestern College students pose in 1923, during the "Booster Day" activities. (Courtesy of North Central College archives.)

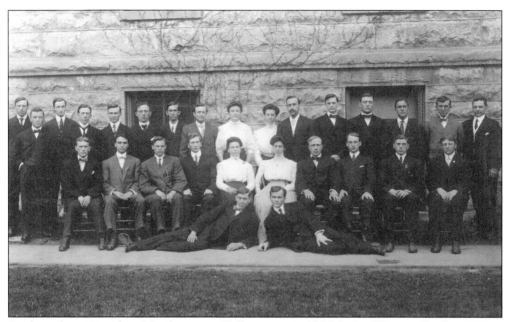

Students from Canada at Northwestern College pose in 1906 during "Booster Day" activities. Each state would gather for a class picture during this week. (Courtesy of North Central College archives.)

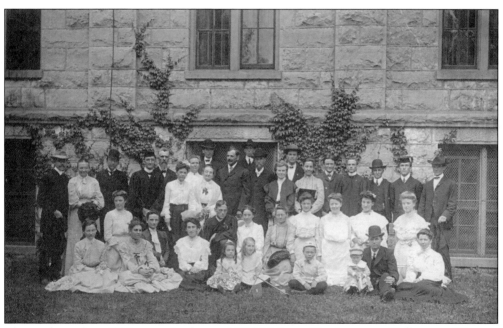

The students from Ohio pose in front of Old Main at Northwestern College on "Booster Day" in 1906. The first college president was Mr. Augustine A. Smith (1861–1883), and he came from the state of Ohio, so the student numbers were high from that area of the country. Previously, in 1872, both Frederick Lewis Maytag, founder of the washing machine company, and John Warne Gates, founder of Texaco, were students at the college. (Courtesy of North Central College archives.)

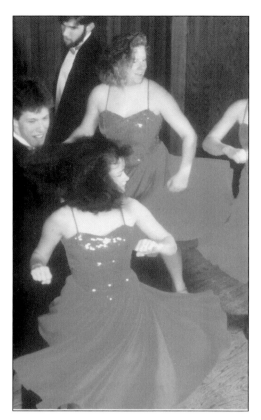

"Swing and sway to the music of Sammy Kaye. . ." seemed to be the sounds that these dancers at North Central College heard! The rhythm of their poses and the swirl of their skirts is so inviting! Let's dance! (Courtesy of North Central College.)

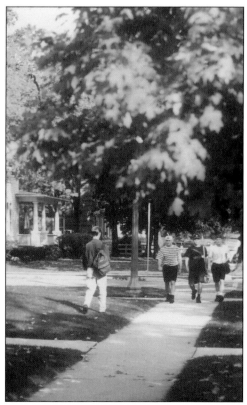

An autumn walk to class seems to be enjoyed by these North Central College students. (Courtesy of North Central College.)

Pictured here is a North Central College football game in the late 1990s. Two young female students are enjoying the fact that their team won this day! (Courtesy of North Central College.)

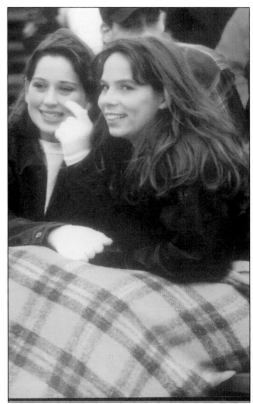

Ah, the thoughts of youth are long, long thoughts, penned the poet. Here are five North Central College students—youthful , smiling, full of life's energy. Ruskin wrote that, "Every noble life leaves the fiber of it interwoven forever in the work of the world." I am sure their contributions to society have been greatly enhanced by their college degree from North Central College! (Courtesy of North Central College.)

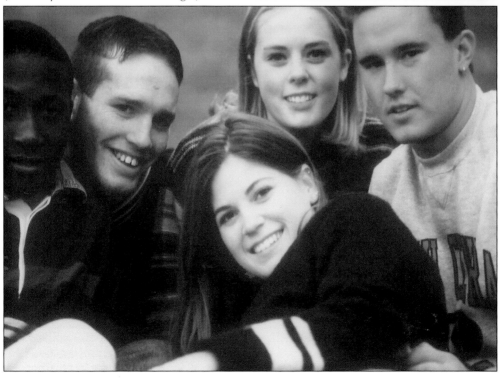

Northwestern College began with 243 students in 1861 in Plainfield, Illinois. In keeping with the Evangelical tradition, instruction was offered in both English and German. In 1869, the citizens of Naperville offered $25,000 to the college trustees to bring their school to the two-block site offered by Morris Sleight. In those post-Civil War times, that was a significant amount of money for the 3,000 residents to raise! According to Genevieve Towsley, the cornerstone of Old Main was laid in the spring of 1870. It was "an elegant and commodious stone edifice conveniently arranged." In 1926, the institution became known as North Central College. (Courtesy of North Central College.)

A solitary jack-o-lantern poses on the porch. Sunlight warms the windows on this brisk October day on the North Central College campus in Naperville. "I am a jack-o-lantern with terrible teeth," wrote Carl Sandburg, "and the children know I am fooling." (Courtesy of North Central College.)

*Eight*

# A Visit to Kroehler Manufacturing/ 5th Avenue Station

*"History," wrote Churchill, "with its flickering lamp stumbles along the trail of the past, trying to reconstruct its scene, to revive its echoes, and kindle with pale gleams the passion of former days."*

At the turn of the twentieth century, the Light Guard band played its concerts from a covered bandstand in Central Park. On the east side of Ellsworth Street there was a beautiful grove of flowering locusts and Dutchman's breeches and dogtooth violets. Individual talent and imagination provided the fire that brought pleasure and family and business fulfillment. Recreation included carriage horses for sleigh rides and ice skating on frozen ponds. Bonfires provided light as well as heat.

What began in a skating rink in 1893 as the Naperville Lounge Company became Kroehler Manufacturing Company and the town's only industry! Between 1911 and 1920, the building became a four-story, red brick manufacturing plant that stretched two blocks alongside railroad tracks. Its founder, Peter Kroehler, a Minnesota farm boy, arrived in Naperville in 1890, to study business at North Western College (now North Central College). At age 31, he was named president of the company at a salary of $5,000. Peter was known as "Six for a Quarter Pete" because of a marketing idea he used when he offered six lounges for $25.

The Kroehler building was vacated in 1978, when operations ceased. Development partners in 1986 instituted a $17 million renovation. The complex combines a unique shopping mall, atrium office area, 118 apartment residences and restaurants.

Marian Richards Furnas is seated in her kitchen during the Christmas holidays, 1988, at her home at 202 Westlawn in Aurora, Illinois. Marian lived to be 94 and died on March 18, 1992. Marian Furnas, my dear friend, worked at the Kroehler firm in 1920. "I was secretary to the advertising manager then," she said. "I took the local train to work. I worked from 8:00 a.m. to 6:00 p.m. with 1.5 hours for lunch. Since there weren't any restaurants in that area, I took my lunch daily. My pay was $12.50 a week. Kroehler was the most outstanding manufacturer of davenports at that time. Their business thrived. I remember seeing one of the Kroehler nephews sitting with an eyeshade working on his inventions! P.K. Kroehler would come to Naperville once a week from his Chicago office," she continued. "We wore business dresses or suits then, and everyone was addressed by Mr. or Miss, so I was Miss Richards. The men wore coats and ties too." (Photograph by Jo Fredell Higgins.)

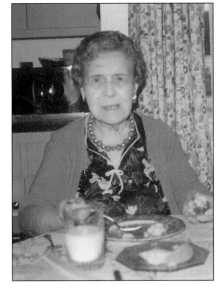

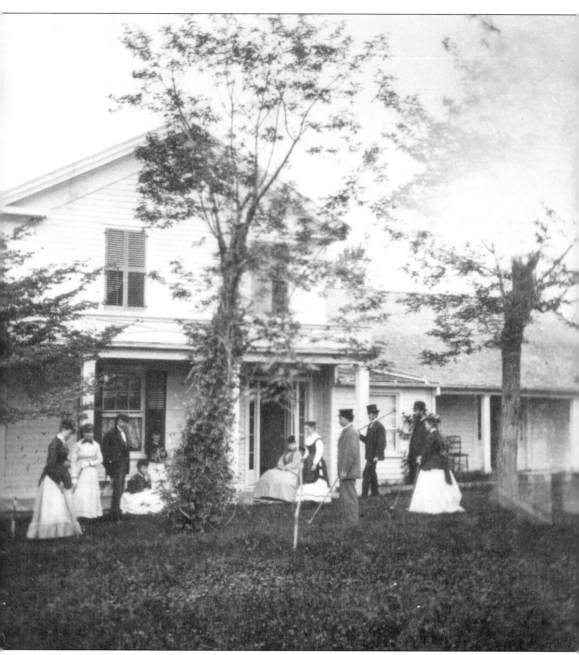

These individuals are playing croquet on the lawn in front of the Ellsworth House on what is now the Fort Hill campus, probably in the late 1800s. This scene is from the Sleight home on Cottage Green at Ellsworth Street and Chicago Avenue in Naperville.

Changing a tire is as old as the first Model T! Seen here in downtown Naperville in 1941, are Edward Mertz and a friend. They had the task of changing the flat tire on Ralph's car. (Courtesy of Dyonne Brys.)

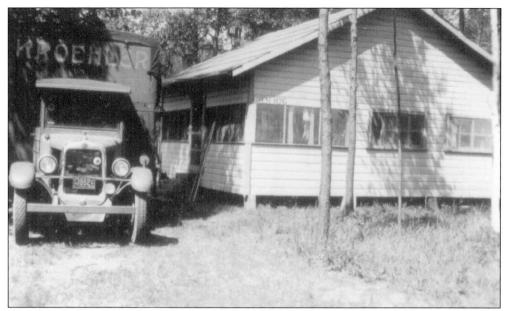

This is another view of the Kroehler truck that Ralph Mertz drove, c. 1930. (Courtesy of Dyonne Brys.)

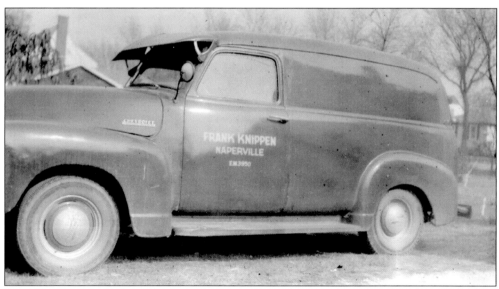

Frank Knippen worked for the City of Naperville as an electrician, and this photo was taken in the early 1940s. Naperville remained primarily a farming community. The population was 5,280. There were 800 students attending North Central College. There were 20 churches. The Kroehler Manufacturing Company's furniture plant employed about 900 local residents. On the CB&Q Railroad, there were 1,000 people who commuted each week into Chicago. It was the time of Mayor J.L. Nichols, Centennial Beach, the G.I. Bill of Rights, jet propulsion, ticker tape parades, the Marshall Plan, war brides, and Tokyo Rose. (Courtesy of Dyonne Brys.)

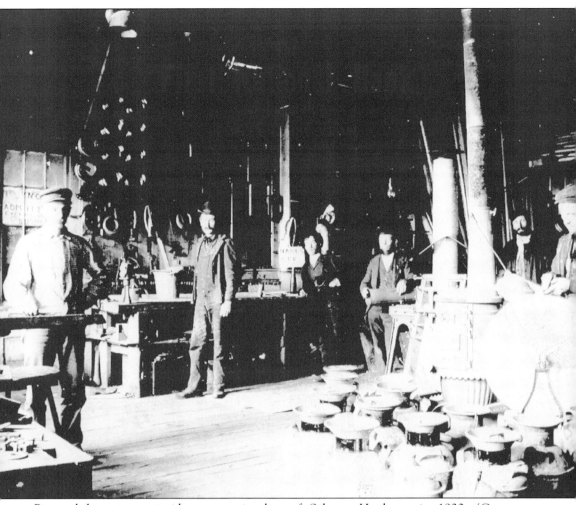

Pictured here is an inside panaromic shot of Scherer Hardware in 1920. (Courtesy of Dyonne Brys.)

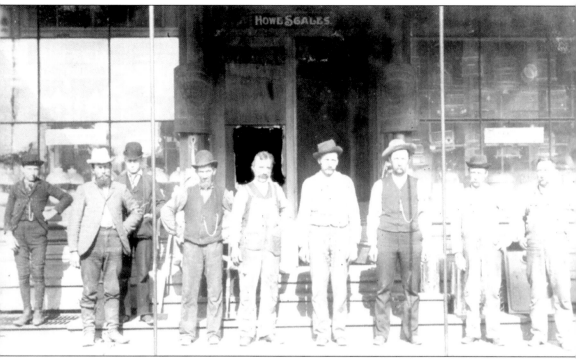

In 1920, the men who worked for the Scherer Hardware and Blacksmith Shop knew their trade quite well. They probably supplied much of the material that went into building the YMCA. The laying of the cornerstone was held on May 30, 1910. Previously, the Nichols library had been dedicated on June 29, 1898. For this construction also, Scherer Hardware supplied the building materials, including the nails and tools used. When the library opened, it contained 500 volumes, which had been bought and 200 books that had been donated. (Courtesy of Dyonne Brys.)

To Report a Fire
Ask For
**Naperville 21**

To Call the Police
Ask For
**Naperville 28**

# NAPERVILLE

BELL SYSTEM

# TELEPHONE DIRECTORY

## August, 1931

See page iii for list of other Exchanges included in this Directory

## TELEPHONE SERVICE CALLS

**ASK FOR**

For numbers not listed in this directory..........Information

For placing station-to-station calls to near-by points
(see list on page vi) give call to your ..........Operator

For placing Long Distance calls...................Long Distance

If calls are not completed satisfactorily or for
assistance in calling........................Supervisor

To report telephone "Out of Order"...............Repair Service

For business transactions—
Applications for service, moving of telephones,
bills for service, directory listings, etc.........Naperville 9981

To notify the Company if your requirements are
not met by calling as outlined above,
call the Manager (charges collect)...........Aurora 9995

*To Get the Best Use of Your Service See Pages ii to viii*

Some of the services and products listed in this August 1931 telephone directory include taxicabs, tailors, rug cleaners, seven meat markets, mushrooms, one ice dealer, bakers, banks, St. Joseph Bohemian Orphanage in Lisle, delicacies, cigar stores, four confectionery stores, thirteen clergymen, and seven coal companies. (Courtesy of Evelyn Stearns.)

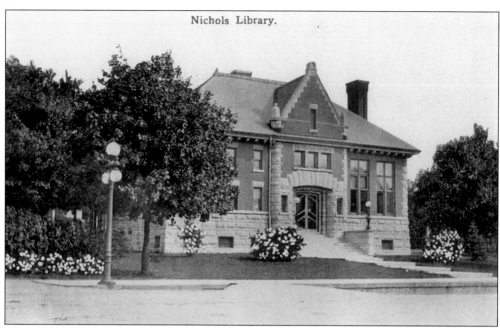

Nichols Library.

James L. Nichols bequeathed $10,000 to the city for the purpose of erecting a library. After his death in 1895, the library project board selected a location at the west edge of Central Park, and M.E. Bell was chosen as architect. Alvin Enck was awarded the contract for $7,498. In October 1898, the cornerstone was laid, and on September 22, 1898, the library was officially opened with a book donation party. (Postcard courtesy of Ray Kinney.)

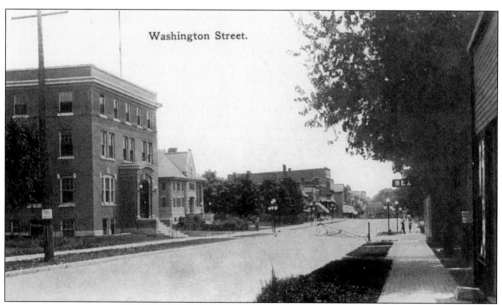

Washington Street.

Washington Street is shown here in about 1910. The brick pavement was laid on this street and in the business section this year. Naperville's population stood at 3,400. Telephone cables were installed underground by the Chicago Telephone Company. A local newspaper columnist wrote that, "the man with the callous, the plumber, the carpenter, the farmer, is the present aristocrat among those of you who moil for money." (Postcard courtesy of Ray Kinney.)

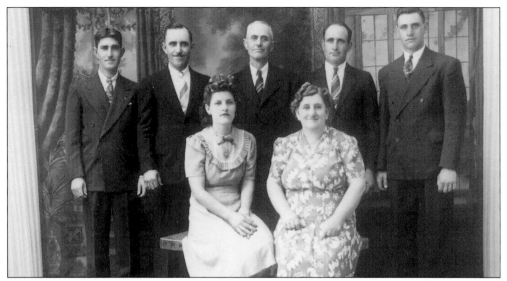

This is a family portrait of the Henry Boldt's, c. 1930. The two seated women are Dorothy Boldt Bieniak and Ella Schrader Boldt. The men standing, from left to right, are: Leonard Boldt, Harvey Boldt, Grandfather Henry Boldt, Clarence Boldt, and Orman Boldt. During the Depression, many lost their farms and belongings. They may have thought they had lost everything. In reality, they still had what counts—their parents, their friends, and their loved ones. As someone wrote at the time, "What a gift to have all that. The riches in the world are in the people you love." A family portrait such as this reminds us all of the dignity of cherished loving. (Courtesy of Clarita Boldt.)

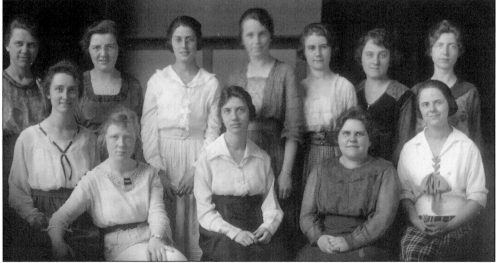

We see here a group of North Central College women but, sadly, they are unidentified! It remains, however, a compelling portrait. Who were these daughters, these sisters, these studious women? Romantic fiction created an ideal of the softly genteel but indomitable female. *Vogue* magazine had warned at the turn of the 19th century that such "literature as Ibsen, Zola, and Shaw were taboo and not fit reading for decent people." Can we question women's energy born of personal conviction, which led her to pursue higher education? Then or now, it remains the ideal. (Courtesy of North Central College archives.)

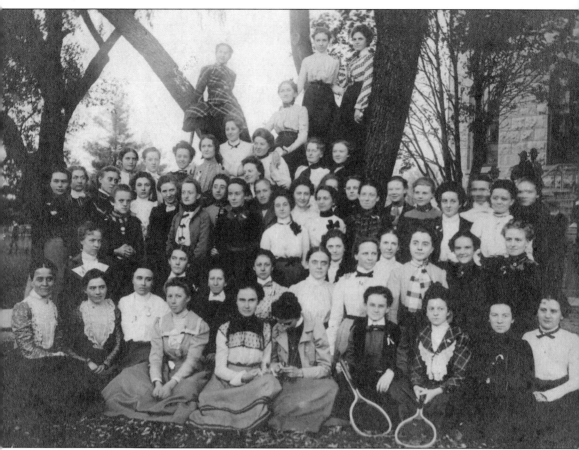

This marvelous photo, c. 1911, is unidentified of North Central College women. Beautiful dresses, bright and sassy smiles, tennis rackets in hand, they came together on this summer's day to pose for the camera. I am so thankful they did! The latest tennis racket at the time had a grooved grip and fishtail handle. Imagine playing tennis in those long billowy skirts! Annual May field days were begun in 1890, to encourage the students to exercise. By 1896, there were competitions in baseball and track events. There was also a tennis tournament. Literary presentations and musicals were also included during these events. (Courtesy of North Central College archives.)

# Nine

# IDYLLIC AND CONTEMPORARY

*"Memories, like falling snow are better left free, distractingly lovely, even in flight."*
—Jo Fredell Higgins

*E*legance *was the watchword at Christmas time, 1931. Mr. Coolidge was president and Pius XI was Pope. It was an innocent time, a blithe spirit time. It was a romantic era. Correct dress for women included four-button, hand-sewn gloves, brown taupe hosiery, coats made of tweedy-looking material with fur shawl collars, and wool suits. Patou created a turquoise satin blouse with Persian embroidery to wear with his wool suit and called the ensemble "Seduction." Christmas 1931 tea hour could include such delicacies as chocolate fudge, noel charlotte russe, white plum pudding, wassail bowl, malt cocoa, tea, and coffee.*

*Christmas, like the seasons, like success, comes suddenly to the city of Naperville. It sings its song of life, ever so resolute and beautiful. We are carried forward. Though individually written, the chorus rises to its ultimate crescendo. Each player in his or her own tempo lives out destiny's path.*

*From the Naperville diary of Guy E. Sabin, Saturday, February 25, 1871, we read that "ground covered with snow this morning. Great for a sleigh ride. Will exercise the horses some of these moonlight nights." Guy had fashioned a hickory nut ring and basket for his sweetheart Nannie Sevier. Those still exist today, according to his great granddaughter Pat Sabin.*

*Those stalwart pioneer men and women who built their log cabin homes and who survived the Midwestern winters created this remarkable city. . . this Naperville, Illinois, city community, that is both idyllic and contemporary.*

Mary Ann and Brand Bobosky epitomize today's committed and involved couple. Mary Ann is director of community relations for Naperville Community Unit School District 203. W.

Brand Bobosky has served the Naperville community as president of the Naperville Area Chamber of Commerce, the Naperville Jaycees, and as president of the Naperville Rotary Club. Brand introduced and promoted an exciting public arts program called Century Walk. Several years ago, a group of residents convinced the city council to partially fund this unique project through hotel/motel taxes. The group also obtained grants from the Illinois Arts Council and from private donors. Beginning in 1996, a distinctive art piece, mural, mosaic, relief, or sculpture has been commissioned and placed downtown as part of Naperville's Century Walk. Brand and Mary Ann have four children and three grandchildren. (Photograph by Jo Fredell Higgins.)

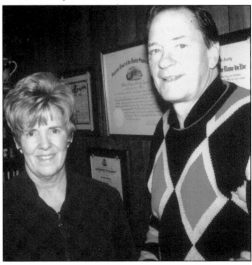

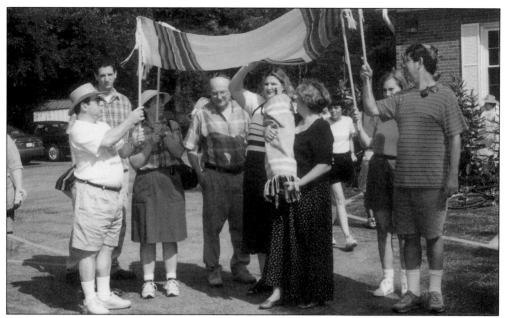

On Sunday August 23, 1998, members of Beth Shalom carried Torah Scrolls to their new synagogue. The congregation has 350 family members, and their new house of worship is located at 772 West Fifth Avenue in Naperville. The parish is one of the current 90 houses of worship in the city. (Courtesy of Bill Gommel, The Picture Man, Inc.)

Tom Klingbell is pictured at the City Meat Market in 1979. The sausages look quite appetizing, don't they? The market first opened for business in 1890. (Courtesy of Bill Gommel, The Picture Man, Inc.)

This May afternoon was such a harbinger of the spring season's warm weather. The City Meat Market opened in 1890, with Charles Bottger and his three sons operating it. A number of other owners subsequently took over the business until August 10 1998, when Tom and Deborah Klingbell sold the shop to Jeff and Rae Andrews." We offer friendly service and quality meats," said Jeff on this busy May day. "Our innovative approach offers both ready-to-cook entrees as well as many fine cuts of meat, and the Hokay turkeys are also sold fresh for the Thanksgiving table."

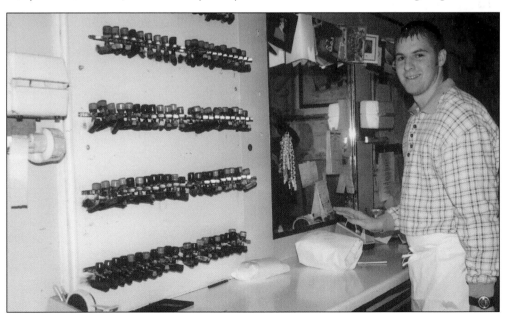

Chris Ciampi packages up some meat for a customer at the City Meat Market in December 2000. Business is usually brisk during holiday seasons, and many fresh turkeys are sold for the dinner tables of the families nearby. (Photograph by Jo Fredell Higgins.)

John Case sits on a stack of PAG hybrid seed corn at their warehouse in Naperville. It is the planting season of 1979, and a busy one it was. (Courtesy of Bill Gommel, The Picture Man, Inc.)

This photo depicts an iron worker at the DuPage Boiler Works in 1979. (Courtesy of Bill Gommel, The Picture Man, Inc.)

The Bank of Naperville is shown here in 1979. (Courtesy of Bill Gommel, The Picture Man, Inc.)

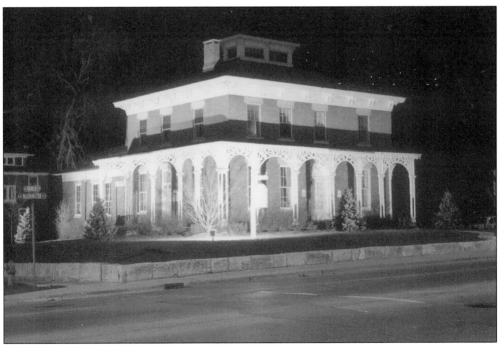

This beautiful red brick building is the office of Fawell, James, & Brooks, 1979. (Courtesy of Bill Gommel, The Picture Man, Inc.)

On a frosty winter's day in December 2000, the home of the Barzi family at 306 South Jefferson looked very seasonal and attractive. Inside the warmth of the home, family members were gathered around their Christmas tree enjoying the pleasures of the season. (Photograph by Jo Fredell Higgins.)

Patricia Riley was ringing the bell for the Salvation Army this December evening in 2000. Patricia was one of the members of the Lucent Technology team who participated in this annual fund-raiser. The evening's chill did not seem to damper her enthusiasm for her task! (Photograph by Jo Fredell Higgins.)

Nike Sanghvi, Usha Sanghvi, and behind them Sushila Patel were all preparing for the Christmas Eve 2000 rush as I snapped this photo. Nike wore a sign that read, "Open 24 hours on Xmas Day." Their Mr. Donut shop by the Fox Valley Mall at the corner of Aurora Avenue and Rt. 59 in Naperville is always busy. (Photograph by Jo Fredell Higgins.)

The Third Gift from the people of Naperville flyer is shown here.

# The Third Gift
## From the People of Naperville

| In 1931, the people of Naperville gave us Centennial Beach | In 1981, the people of Naperville gave us the Riverwalk | In 2000, the people of Naperville are giving us the Millennium Carillon |
| --- | --- | --- |

**Millennium Carillon**

Phase I of the Millennium Carillon has now been completed at a cost of 4.2 million dollars. This includes the completion of the instrument composed of 72 bronze bells ranging in weight from ten pounds to almost six tons and spanning six octaves. Out of six hundred carillons world wide, the Millennium Carillon is one of only four this size and is properly know as a Grand Carillon. Phase I also includes partial completion of the 168 foot tower. A 1.5 million dollar line of credit generously provided by the City needs to be retired before Phase II begins.

Phase II will complete the tower by adding glass up to the level of the belfry, installation of permanent stairs, an elevator, a year-round visitors' center, an interactive time-capsule, cut limestone on the first twelve feet of the exterior of the tower and opening the observation deck at the 135 foot level. Phase II will also include building a terraced performance plaza on the east side, a reception plaza and reflecting pool on the west side and landscaped gardens. It will cost an estimated $2.3 million dollars to complete.

**Catch the Spirit!**

Like The Riverwalk and Centennial Beach before it, the Millennium Carillon stands as a tribute to the generosity of our citizens and their devotion to leaving a usable, community asset for generations to follow. The Carillon will leave a lasting, timeless legacy of music which has already been enjoyed by thousands. We hope that you will review the donor levels and benefits outlined in this brochure and choose to become a part of this magnificent historic project.

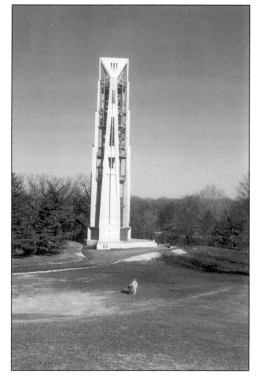

An early spring day at the Millennium Carillon reminds the listener that the four cornerstones of the limestone tower represent Naperville's core values of community, family, education, and commerce. The melodious sounds of the 72 bronze bells can be heard throughout the downtown district. Their tones seem to sound the praises of a prosperous and beneficent society. (Photograph by Jo Fredell Higgins.)

# BREAKFAST OF CHAMPIONS

Naperville North's principal, Mr. Lorenz, instituted a new program for the school the year. This program, titled "You Make a Difference," was established to recognize students for their achievements. Mr. Lorenz implemented this plan into yet another way to recognize outstanding students at Naperville North. He believes some students are not commended for their achievements. These achievements include performances in sports, extra-curricular activities, or academics, leadership inside and outside the classroom, and simple, good deeds any day of the week. Students are honored by having breakfast with their teachers and parents The students' parents, their teachers, and Mr. Lorenz are thrilled to have the opportunity to tell them Naperville North would no be the school it is today without their leadership.

Mr. Lorenz announces the program at the first breakfast

Junior Ryann Hubbard with parents and Mr. Ryan

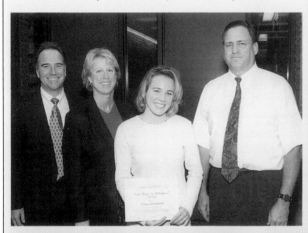

Senior Trace Carter with Mrs. Martin

Jacki Marino with Miss Sola

Mary Agnes Funchion visited Naperville in 1988. She came from Gorey, Ireland, County Wexford to visit her son Bill and family. Mary Agnes was 80 years young in this photo. What a pretty smile! (Courtesy of Bill Funchion.)

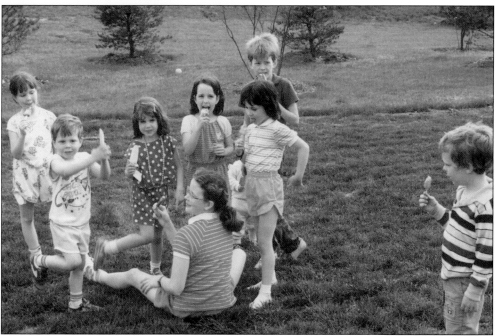

Children and popsicles seem made for one another, don't they? Here we see extended family members of the Bill Funchion family enjoying their afternoon at the Spring Hill Park in Naperville in 1985. (Courtesy of Bill Funchion.)

Mona Catherine Funchion looks reflective on her First Communion Day in 1983. As her Irish ancestors would say, "My what a lovely lass, yes, she was." (Courtesy of Bill Funchion.)

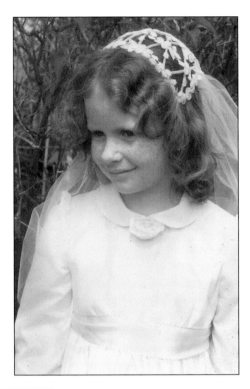

Mona Catherine Funchion was a guest voice soloist with the Glen Ellyn Children's Choir at Carnegie Hall in New York in 1991. She is shown here in all her radiant joy. Sadly, two years later, May 28, 1993, Mona Catherine was called home. She died of a very rare cancer. Now that she is among the angels, her musical gifts are being showered to us below. May her dear soul rest in peace. (Courtesy of Bill Funchion.)

The White Eagle Club is a unique community development in the affluent Aurora-Naperville corridor. White Eagle encompasses 754 acres of luxury living with an 18-hole Arnold Palmer Signature Golf Course and man-made recreational lakes and parks. The genius behind this development by Macom Corporation is Harold Moser. He believed that his word was his bond, and a handshake closed many deals. "Make people happy by dealing with them in an honest manner, and place customer satisfaction at the top of the priority list," he has said. This beautiful home pictured is the home of Marilyn and Don McKay on Pine Lake Drive. (Photograph by Jo Fredell Higgins.)

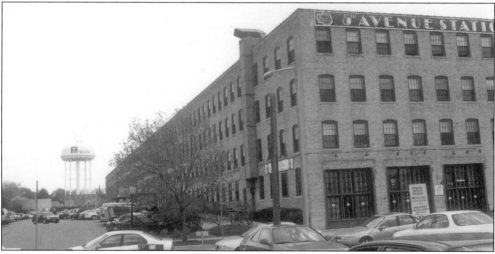

The Naperville water tower can be seen in the background in this photo of the Fifth Avenue Station retail/restaurant/apartment complex. Housed in the former Kroehler furniture factory, this is also the location for the summer farmer's markets held each Saturday from June to October. Members of the Naperville Garden Club especially enjoy this summertime market. The Garden Club began in July 1927, and "nearly 40 ladies" attended the first meeting. They presented a flower show in May of 1928, and on February 19, 1929, the first officers were elected. They offer the "Cup of Cheer" housewalk each holiday season and an art show each summer. (Photograph by Jo Fredell Higgins. History from *History of the Naperville Garden Club*, August 1995.)

Naperville has enjoyed a thriving historic downtown area with many small, quaint shops offering imported goods, foods, or services. Truffles is one example of an eclectic boutique that offers baskets as well as gardening accessories, photo frames, linens, silk flowers, and watering cans. Situated on Jefferson Street, it is close to the picturesque Riverwalk, the outdoor sculptures, the library, bookstores, and the ambiance of quiet gentility that is downtown Naperville. (Photograph by Jo Fredell Higgins.)

Lindsay Olson, age 11, was enjoying the dandelion fountain on a recent May afternoon. The fountain contains 51 rods that form the dandelion shape. "I am in fifth grade at May Watts School," she said. It was a fine time to sit and enjoy the Riverwalk view, as many others were enjoying the scene too. The Riverwalk is operated by the park district and is beautifully maintained. The distinctive shepherd's-crook light poles are situated along the 4 miles of winding brick paths along the DuPage River. There are monuments with the names of Naperville's old farm families and a paddleboat quarry where colorful paddleboats can be rented for a fun respite during the season. (Photograph by Jo Fredell Higgins.)

# WEB LINKS

http://naper.il.usa.mayor
http://patsabin.com/dupage
http://www.naperjaycees.org
http://www.napersettlement.com
http://www.naperville.com
http://www.naperville-lib.org
http://www.northcentralcollege.edu

# BIBLIOGRAPHY

*150 Years of Sharing the Word.* SS Peter and Paul Parish, June 1996.

*A Shared History 1870–1995.* Pierre Lebeau and Ann Durkin Keating, May 1995.

*District 203 History.* Phoebe Bickhaus, District 203 Public Information Coordinator.

District 204 History information given by Penny Catour.

*Downers Grove 1832–1982.* Montrew Dunham and Pauline Wandschneider, Downers Grove High School, 1982.

*Du Page at 150 and Those who Shaped Our World.* Jean Moore and Hiawatha Bray, 1989.

*DuPage County Atlas,* 1874, published by Thompson Bros. & Burr of Elgin, Illinois. Courtesy of W. Brand Bobosky, attorney at law.

*DuPage Discovery 1776–1976.* DuPage County Bicentennial Commission. Herbert S. Wehling, 1976.

*Historic Naperville.* Liza Netzley Goehring.

*History of the Naperville Fire Department.* 125th Anniversary, 1874–1999. Walsworth Publishing Co., Marceline, Missouri.

*In and Around Historic Warrenville.* Leone Schmidt, Warrenville Historic Society, 1982.

*It's Naperville.* Herb Matter, Column collection from *The Naperville Sun,* 1978–96.

*Kane County History Atlas,* Aurora Historical Society.

Naper Settlement Archives.

*Naperville Area Farm Families History.* Naperville Farmers' Riverwalk.

Naperville Census Data.

*Naperville Centennial 1931–1931.* The Naperville Sun, 1975.

Naperville Homecoming Souvenir, June 1917. *The Naperville Sun,* 1976. Naperville, 1997.

*The Naperville Sun.* "The Naperville Woman's Club," Jean Schmus, 1952–53.

*Our Town In Illinois.* Illinois Sesquicentennial Section, August 22, 1968.

*Snapshots of Our Past.* The Naperville Sun publication.

*The New World Book of Meyers.* Volumes One and Two. Courtesy of W. Brand Bobosky.

*Threshing from Farm Town: A Memoir of the 1930s.* Grant Heilman, Stephen Greene Press, Vermont, 1974.

*We Are Family.* History of the Pre-Emption House and the Gertrude Hiltenbrand-Wehrli Family. Joyce Elizabeth Wehrli, Naperville, Illinois, 1993.

# ABOUT THE AUTHOR

JO FREDELL HIGGINS is an internationally published writer and award-winning essayist and poet. She holds a master's degree in education and has taught pre-schoolers to 90-year-olds during her teaching career. Her photographs have won numerous awards. One was selected to be included in the *One Day USA* book published by the U.S. Conference of Mayor's. Jo is currently the volunteer coordinator for the Adult Literacy Project at Waubonsee Community College in Aurora, Illinois. She has presented at local, state, and national literacy conferences. Her volunteers have won local, state, and national awards. Jo serves as chair of the G.A.R. Commission, as vice-chair of the Aurora Township Youth Commission, is president of the board of directors for the Townes of Oakhurst, and serves on the Aurora Township Foundation board. Her photo exhibits have been shown at the Aurora Public Library as well as First Night Aurora celebrations. Jo's articles have been published in *The Instructor, Teacher, Today's Catholic Teacher, Illinois* magazine, *Child Care* magazine, and Dublin, Ireland's *Reality* magazine, as well as 40 other publications. Her poetry has been published in *Her Echo*, a women's poetry anthology; in *New Voices in American Poetry 1975*; in the Indiana Fine Arts Society's "The Poet," the Morton Arboretum's "*White Words of Winter*" anthology, in "*A Different Drummer,*" New Jersey, 1977, and in *Poems of the World* anthology in 1998, 1999, and 2000. Jo volunteers with the Fox Valley Hospice, the Morton Arboretum, and the Salvation Army. Jo is a book reviewer and columnist for the *Beacon-News*. She enjoys gardening, swimming, traveling, bicycling, and card games. Her daughter Suzanne and grandson Sean live in Madison, Wisconsin.